Changing Impressions: Marcantonio Raimondi & Sixteenth-Century Print Connoisseurship

CLAY DEAN

THERESA FAIRBANKS

LISA PON

Yale University Art Gallery ~ 1999

Introduction & Acknowledgments 4
RICHARD S. FIELD

Colorplates 9

Essays

Changing Impressions on Parchment:
Marcantonio Raimondi's *Mars, Venus, and Cupid* 22
CLAY DEAN

The Mystery and Mystique of Printing on Parchment 44
THERESA FAIRBANKS

Marcantonio Printing / Printing Marcantonio 60
LISA PON

Checklist of the Exhibition 75

Introduction & Acknowledgments

THE CHALLENGE OF THIS UNDERTAKING was clear from the outset: could careful scientific and art historical analyses yield new information about an almost unique group of prints on parchment, all pulled from a copper plate engraved by Marcantonio Raimondi in 1508? The significance of these impressions of *Mars, Venus, and Cupid* was raised for the very first time in 1961 by Henri Zerner. He concluded, based on knowledge of the one impression in his personal collection, that the peculiar alterations of the image were intended to produce prints that could be mistaken for "proof" impressions — prints pulled from the plate before the artist had completely engraved his design. That Zerner's "proof" was on parchment rather than paper reinforced his contention that it was intended to raise expectations of rarity and preciousness. Zerner concluded that such prints confirmed the existence of sophisticated print collectors in Italy during the very early years of the sixteenth century.

In 1981, the problem was revisited by Innis Shoemaker and Elizabeth Broun in their exhibition of Marcantonio prints. They added two further impressions on parchment (from the collections at the University of Kansas and Yale) and argued that these prints, with their masked passages, were attempts to "recreate the first state." As had Zerner, they felt that such "proofs" must be regarded as evidence of a highly developed print connoisseurship, by which they seemed to have meant the kind of thirst for rarities that was to develop for the states of Van Ostade's prints in the seventeenth century or for Rembrandt's and Whistler's in more recent times.

The present exhibition has added a fourth impression on parchment (from the stock of Hill-Stone, Inc.) as well as a completely unknown but similarly altered print on parchment by Marco Dente. Clay Dean's and Theresa Fairbanks's careful analyses make clear that there are grounds for doubting that the makers of these parchment impressions were trying to recapitulate known first states. In fact, this catalogue assumes that such knowledge was not avail-

able. One reason for this is that all four impressions of *Mars, Venus, and Cupid* tinker with passages that were present in the first state, most notably in the Hill-Stone impression where the entire original figure of Cupid was masked out. Further, we are not at all certain that these so-called proofs were executed during the early years of the sixteenth century. If they were not, one would have to reconsider any generalizations about the nature of print collecting at the beginning of that century.

But first I would like to insert my own view of the data we have at hand. Based on consideration of as many originals as I have been able to "examine"—personally, at second hand with the help of colleagues' eyes, and through photographic reproductions—there appears to be a cluster of observations that undermines one or two basic suppositions about the variables in this case. First is the fact that every single example of the second state of *Mars, Venus, and Cupid* manifests the same scratches and flaws, including—most critically—the long diagonal swatch that extends over Mars's body into Venus's. This particular passage is the result of an accident to the plate: it was bent or somehow dented at some time in its history. Second, all of the four parchment impressions of *Mars, Venus, and Cupid* show the identical scratches and damage to the plate as the second states on paper; there appears to be but one new scratch, near Venus's forehead, but even this may be seen in the paper impression at Veste Coburg. Third is the circumstance that we have failed to uncover even one impression of the second state printed on paper that may be securely dated to the early decades of the sixteenth century. In fact, the watermarks we have identified all suggest much later dates, from the middle of the century and later.

These observations suggest a scenario that I find worth pondering. During the course of pulling impressions of the first state (which may have been spread over some time), the plate was damaged. It was put aside by Marcantonio and never printed again until it came into the possession of some other party after his death. At that time, new work was added, perhaps to fill out the composition in order to distract from the damaged passages, perhaps as a matter of taste for a more pictorially finished image. Whatever the reason, Marcantonio was not the author of the new passages: the Medusa head, the torch and its staff, quiver, landscape, and other minor additions. As Clay Dean points out, Marcantonio never altered any of his plates as extensively as this; and as David Landau has made clear, most of the forty-odd of Marcantonio's plates that are known in more than one state were revised with but minor

adjustments by publishers/printers long after the artist's death. From this I would argue the likelihood that all of the known second states of *Mars, Venus, and Cupid,* on paper and on parchment, were made no earlier than 1540 and possibly much later. The use of parchment has been very carefully thought out by Dean and Fairbanks, who have concluded that while vellum was indeed associated with rarities and dedication proofs, it was also a propitious material for the experimental suppression of details. Passages could be removed from the parchment either by scraping with little wear to the support, or through the use of paper masks that would not deeply emboss the surface of the print.

We have all agreed that our four parchments were experiments, failed experiments if truth be told, and not finished products ready to deceive (though they may have done just that during the intervening centuries). Intriguingly, my colleague Christopher Wood has suggested that if the four surviving parchment impressions were meant to simulate "proofs," they would have benefited by flooding the market with the unaltered second states on paper. Innis Shoemaker recalls vividly the surprising number of these that one can find in museums and regularly on the market (as I write, yet another has been offered by an American auction house).

If the above surmise is correct, what significance might it have for the picture of the collecting habits of the sixteenth century? While one cannot think of recapitulating the brilliantly structured arguments developed by Landau in *The Renaissance Print,* it is clear that I take mild exception to his acceptance of Zerner's views of early sixteenth-century print connoisseurship. Rather, I would prefer to use our revised dating of the parchment proofs of *Mars, Venus, and Cupid* to reinforce the thrust of Landau's overall suggestions, which imaginatively fuse what we know about prints, collectors, and publishers. It is plausible to claim that collectors of the earliest years of the sixteenth century regarded prints as being as original in their conception (design and invention) as drawings. From 1510 until 1530, as Marcantonio and other engravers began to collaborate with major artists such as Raphael, Michelangelo, Giulio Romano, Giorgione, and Titian, the capacities and specific character of printmaking itself came to be valued. Increasingly, printmakers adopted daringly esoteric literary subjects and pioneered highly original technical procedures. But sometime around 1540, the plates of this older generation, for which there was now a growing demand, came into the hands of publishers who were neither artists nor engravers. These publishers not only

crudely retouched and reprinted the older plates, but astutely began to create and satisfy a broader and less intellectual demand for images of every sort, especially of the monuments of antiquity and the Renaissance. This explosion of image-making gave birth to the purely reproductive (non-collaborative) print, whose boring qualities must have contributed to Giorgio Vasari's rather perfunctory attention to printmaking in the *Vite*. The new developments in print commerce were accompanied by a new kind of collector, one who thrived on indexed collections, vast hoards of prints intricately catalogued by a greatly expanded range of subject matter. Such collectors also developed a self-conscious taste for rarities, for states and proofs, for "exceptions" of all description. It was for this post-1540/50 generation of collectors that our parchment experiments were targeted.

∾

This exhibition and catalogue, modest though they may be, have emerged from more than eighteen months of sustained and devoted cooperation among five disparate parties: Christopher Wood, professor of the history of art, Theresa Fairbanks, chief conservator, Yale Center for British Art, Clay Dean, graduate student in art history, and myself, all at Yale, and Lisa Pon, recent recipient of her Ph.D. in art history from Harvard. Such merging of talent, effort, and points of view is one of the mainstays of the pedagogical missions of both the Yale University Art Gallery and the Harvard Art Museums, and it is with great satisfaction for ourselves and for our profession that we have labored and reflected together.

Alas, we are unable to thank in adequate fashion the many, many individuals who willingly gave of their time, expertise, and professional skills in order to buttress our quest to better understand the nature and purpose of these five prints on parchment. First of all, we wish to thank the very special support and interest of the lenders of four of these: Henri Zerner, Leslie Hill and Alan Stone, Stephen Goddard of the Spencer Museum of Art, and Randal Keynes, the owner of the intriguing impression of Marco Dente's *Virgin of the Fish*. They all permitted their prints to arrive months ahead of the opening of the exhibition so that they might be examined in depth both in New Haven and in Boston. Those who assisted us in these technical studies were unbelievably generous, and they include Abigail Quandt of the Walters Art Gallery, Richard Newman of the Museum of Fine Arts, Boston, and Jesse

8 Meyers, preparator of parchment. Other loans have been enthusiastically shepherded by the good services of colleagues in various institutions: Antony Griffiths, Jenny Bescoby, and Janice Reading at the British Museum; Jane Glaubinger at the Cleveland Museum of Art; Stephanie Wiles and Robert Lancefield at the Davison Art Center; Marjorie Cohn at the Fogg Art Museum; Vincent Giroud at the Beinecke Rare Book and Manuscript Library; and Valerie van Volt at the Metropolitan Museum of Art. Each one put up with visits, inquiries, indecision, reverses, and requests for more information and last-minute photographs. We all are grateful to those who listened to our arguments and read our drafts, especially David Landau, Creighton Gilbert, Innis Shoemaker, Leo Steinberg, and Christopher Wood (who brought this project to the Yale printroom in the first place and provided critical support through the entire process). It is with particular gratitude that we thank Suzanne Boorsch of the Metropolitan Museum of Art and Robert Babcock of the Beinecke Rare Book and Manuscript Library for their protracted interest and crucial expertise throughout this project.

Many other colleagues responded to inquiries at the last minute. Our appreciation goes out to Cynthia Burlingham, Richard Campbell, Victor Carlson, Peter Day, Conor Fahy, Sharon Goodman, Jan Howard, Gregory Jecmen, Andrea Lothe, Annette Manick, Daniel Mosser, and Mark Pascale, among others. At home we were aided by the printing and photographic acumen of Joseph Maynard, John Robinson, and Frances McMullen, the perfect guidance of our associate registrar Lynne Addison, the resourcefulness of Kathleen Derringer and Linda Jerolmon, the many favors of Daniell Cornell and the endless work of Lisa Hodermarsky, and the guardianship of our silent big sister, Louisa Cunningham, who has looked after us financially for years. The success of this catalogue, however, very clearly reflects the deeply thoughtful contributions and patience of our editor, Lesley K. Baier, and the sensitive creativity and astute judgment of our designer, Julie Fry. Finally, our efforts have taken public form only because of generous financial support from the Florence B. Selden endowment in the printroom, Jock Reynolds's generous contribution from his directorial discretionary funds, and an enthusiastic grant from The David T. Langrock Foundation in New Haven. We thank you all for your aid and sustenance.

Richard S. Field
Curator of Prints, Drawings, and Photographs

Colorplates

fig. 1a

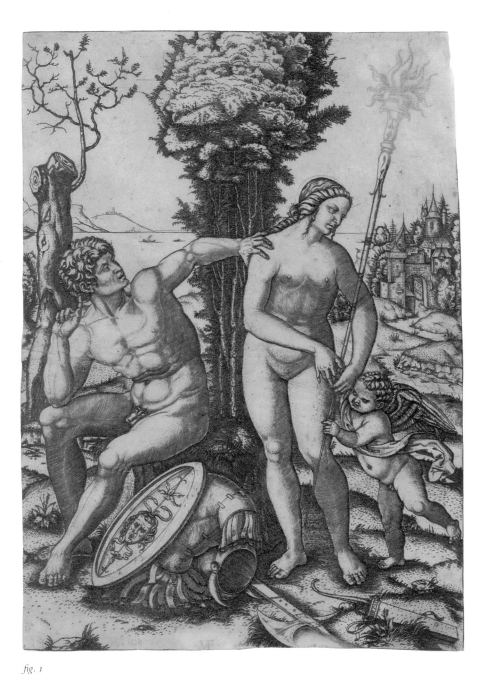

fig. 1

Marcantonio Raimondi, Mars, Venus, and Cupid, *1508. Engraving printed on parchment, 291 x 199. Yale University Art Gallery. Bequest of Lydia Evans Tunnard. 1981.60.27.* The parchment allowed several details — the top of the staff, the flame, the monogram, and the date — to be reduced or eliminated by mechanically scraping the surface. Fig. 1a focuses on the mysterious and still unidentified monogram that was added to the cuirass in the second state. See also the details on the front and back cover. [cat. 4]

fig. 2a

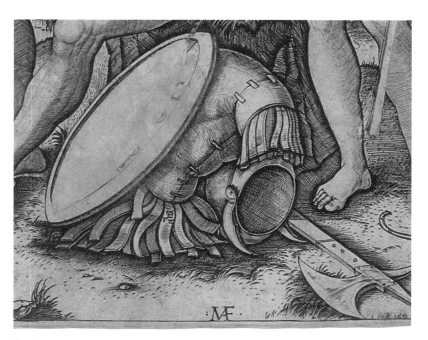

fig. 2b

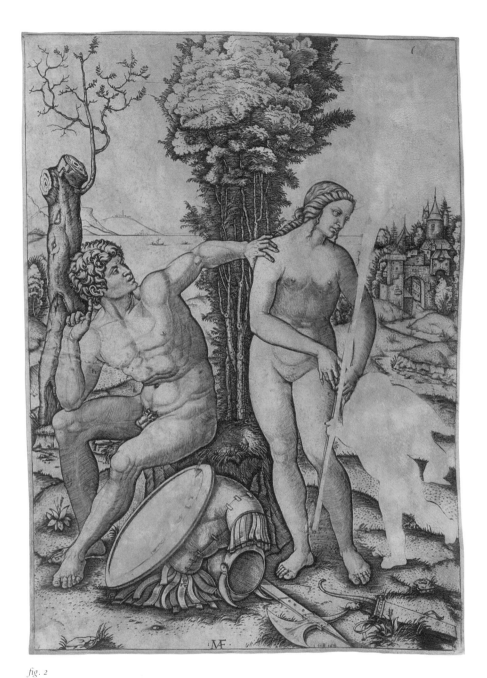

fig. 2

Marcantonio Raimondi, Mars, Venus, and Cupid, *1508. Engraving printed on parchment, 286 x 193. Lent by Hill-Stone, Inc., New York*. Paper templates were used to prevent the center of the shield, Cupid, and the torch from printing. Unique to this impression is the obliteration of an entire figure (Cupid) integral to the composition, rather than just a decorative detail. Note how the template masking the Medusa head slipped a couple of millimeters to the left. [cat. 5]

fig. 3a

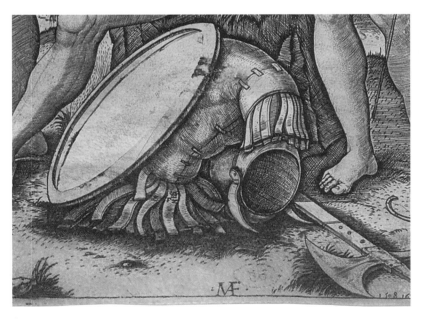

fig. 3b

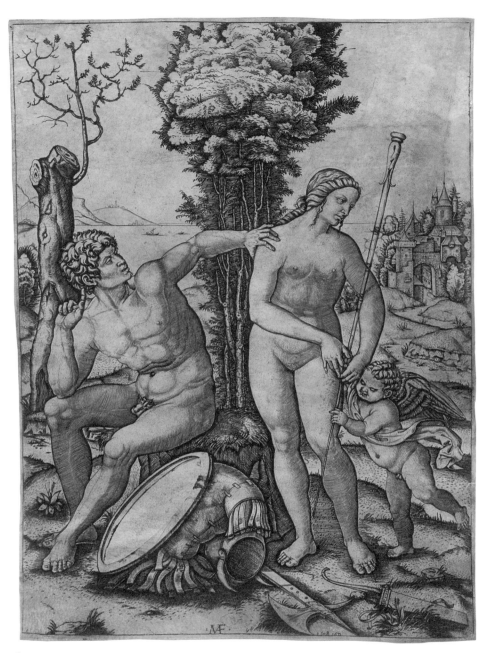

fig. 3

Marcantonio Raimondi, Mars, Venus, and Cupid, 1508. Engraving printed on parchment, 281 x 200. The Spencer Museum of Art, University of Kansas. Gift of the Max Kade Foundation. The paper template used to mask the printing of the Medusa motif was anchored to the plate with ink, some of which has seeped out onto the rim of the shield during printing. A very irregular mask was used to eliminate the flame. [cat. 6]

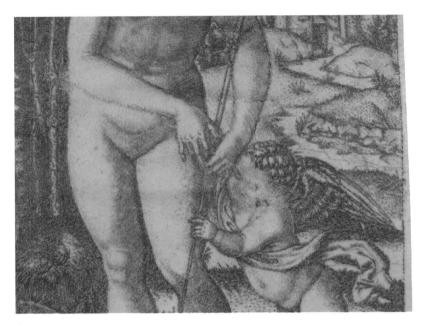

fig. 4a

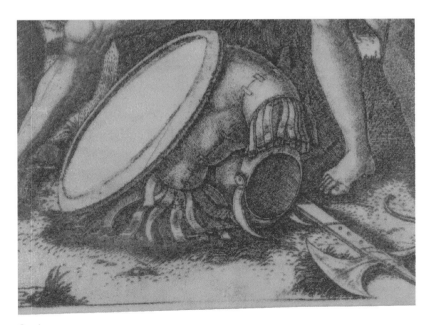

fig. 4b

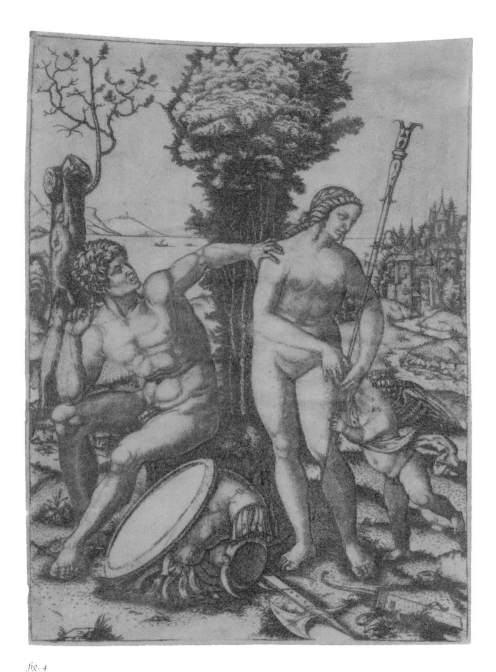

fig. 4

Marcantonio Raimondi, Mars, Venus, and Cupid, *1508. Engraving printed on parchment with manuscript on verso, 290 x 202. Lent by Henri Zerner, Cambridge, MA.* This is a poor impression in part because it was difficult to print on the previously folded and therefore nonplanar parchment, which had originally served as a document. Its yellowish-brown color was caused by a discolored oil or oil/resin surface coating. A template was used to prevent the Medusa head from printing in the center of the shield, while manual scraping of the parchment removed the monogram and the date. [cat. 7]

fig. 5a

fig. 5b

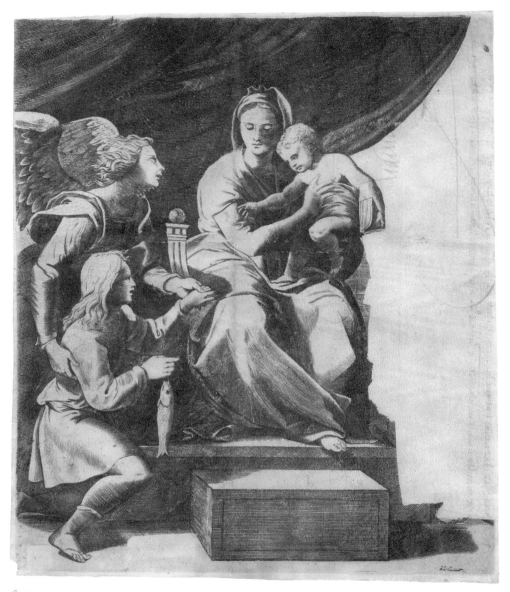

fig. 5

Marco Dente da Ravenna, Virgin and Child with Tobias and the Angel and St. Jerome. *Engraving printed on parchment with traces of manuscript on recto and verso, 258 x 220; B.XIV.61.54. Lent by Randal H. Keynes, London.* This altered impression of the second state (see fig. 13) exhibits the same kind of masking that characterizes the four parchment impressions of *Mars, Venus, and Cupid.* St. Jerome has been masked out on the right, while the publisher's address (*Ant. Sal. exc.*) and a false Marcantonio monogram (MAF) have been masked at the lower left. Careful observation (fig. 5a) reveals remnants of a white pigmented surface preparation, holes from root hair follicles, and traces of the edge of the masking template. [cat. 13]

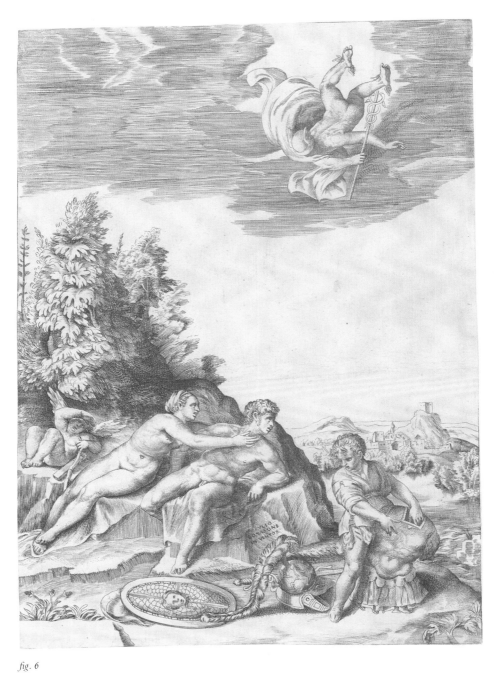

fig. 6

Giulio Bonasone, Calypso Attempting to Detain Ulysses, *ca. 1565. Engraving printed in red-brown ink on paper, 298 x 215; B.XV.154.171. Yale University Art Gallery. Everett V. Meeks, B.A. 1901, Fund. 1999.76.1. An example of a true working proof, printed before Bonasone had completed many details of the sky and landscape. [cat. 15]*

Essays

Changing Impressions on Parchment: Marcantonio Raimondi's *Mars, Venus, and Cupid*

CLAY DEAN

OLD MASTER PRINTS engage connoisseurs not only with their beauty, but also with their peculiarities and problems. Occasionally, the odd or unique print can even baffle experts. The present exhibition and investigation were provoked by a group of four curious impressions of Marcantonio Raimondi's *Mars, Venus, and Cupid,* engraved in 1508 (Bartsch XIV.257.345).[1] A work of the master's early career, the engraving exists in two states and many impressions, some of which are very beautifully printed. The four second-state impressions of concern here, however, are technical anomalies. All four are printed on parchment rather than paper, unusual enough in itself to warrant interest. Still more surprising, each has been individually altered by scraping and/or masking specific elements of the composition.

The first detailed discussion of these alterations occurred at the end of an article by Henri Zerner, published in 1961.[2] Having suggested that the impression in his own collection (fig. 4) was a kind of false proof, Zerner outlined one of the technical methods of alteration involved and laid fertile ground for further research. Twenty years later, in their comprehensive exhibition catalogue of Marcantonio's engravings, Innis Shoemaker and Elizabeth Broun expanded the number of documented, altered impressions of *Mars, Venus, and Cupid* on parchment to three, adding the Yale and Spencer examples (figs. 1, 3).[3] The addition here of the unpublished Hill-Stone impression (fig. 2) brings the total to four. Although all four were printed from the second state of the plate, the alterations to these impressions resulted in images that are neither true to the first nor the second state of the engraving. Changes to the Yale impression involved the destructive scraping of the parchment sheet after the image was printed, whereas changes to the Hill-Stone and Spencer impressions were effected by the nondestructive manipulation of the plate to mask certain areas prior to printing. The Zerner impression contains evidence of both methods.

In bringing these four altered parchment impressions together for the first time, the Yale exhibition has provided an occasion for close comparative study and detailed scientific analysis. The shared physical abnormalities of the objects raise questions about sixteenth-century trends in printmaking and connoisseurship, namely how and why these impressions were made. They may reflect a market for print rarities, as Zerner originally proposed. Understanding more fully the motivations behind this project is the main task at hand. This and other questions will therefore be explored in the context of

what we know of Marcantonio's working methods and the particular history of his engraving of *Mars, Venus, and Cupid*.

⌒

There are only three known impressions of the *first* state of *Mars, Venus, and Cupid*. All are on paper. The best known, a truly handsome impression, is in the collection of the British Museum (fig. 7). The second exists at Chatsworth, and the third in the Kupferstichkabinett, Berlin. Although the first and second states differ in numerous details, both contain Marcantonio's monogram "MAF" and the date "1508 16D" [16 December 1508]. The acronym, which constitutes Marcantonio's most common way of identifying himself in his works, probably stands for the phrase M[arc] A[ntonio] F[rancia].4

The addition of sundry elements and details to the plate created the second state proper (fig. 8). These include the additional tree branches at the upper left, hills along the horizon line above Mars's head, extra foliage in the center grouping of trees, the torch held by Venus, Cupid's quiver, the rivets on the axe handle at Venus's feet, the Medusa head in the shield, and a small and obscured monogram of unknown meaning on one of the leather tassels of Mars's cuirass (fig. 1a). This monogram reads "F" with an "ES" attached perpendicularly to its top, followed by a "Z."5 To a lesser degree, one can observe an augmentation in contour lines both in number and in some cases in thickness, most noticeably in Mars's chest and Venus's legs.

The figures of Mars, Venus, and Cupid create a vertical plane engaging the viewer, formally separating foreground from background. Mars, nevertheless, is quite sculptural, inspired by the famous *Torso Belvedere,* a common source for artists of the period.6 Due to the precisely borrowed pose from the *Torso,* Mars's arm, which Marcantonio has imaginatively extrapolated, extends toward Venus's shoulder in an unnatural manner. Obviously, Marcantonio wanted to copy the *Torso* in its actual position while leaving Venus standing, much as he depicted her — and other female figures — in many of his works. She is less sculptural than Mars, creating a stylistic discrepancy in the composition and suggesting that whereas the artist had a model for the figure of Mars, he may have had to rely on his own invention for that of Venus.

The tight, mushroom-shaped cluster of trees in the center of the composition serves as a formal divide between Mars and Venus and simultaneously

betrays Marcantonio's indebtedness to the printmaking of the North.[7] These
trees were excerpted from Albrecht Dürer's *Combat of Virtue and Pleasure in the Presence of Hercules,* engraved around 1498–99 (fig. 9). The far background, which is also northern inspired, contains faint lines of a hill above Mars's head, while on Venus's side a tortuous road leads to the gate of a quaint Renaissance village with steep roofs and crenellated towers.

Especially in the first state, with its open expanses of sky and its blank, almost mirror-like shield, *Mars, Venus, and Cupid* is relatively empty in comparison to Marcantonio's late works. Indeed, it comes from a transitional period, toward the end of the first decade of the 1500s, when his engravings were beginning to assume a highly finished appearance — an almost opulent, sculptural quality delivered through richer, darker, and more complex printed elements. The changes in the second state, from Venus's flaming torch to the Medusa-head decoration on Mars's shield, all suggest a move in the direction of complexity and support an attribution to the master himself.

Yet Marcantonio did not commonly alter his printing plates by adding major details. Although as many as forty-seven of his plates were reworked (a relatively small number in a corpus of more than 250 engravings), such reworking was largely limited to minor additions, such as numbers or inscriptions.[8] The majority of these alterations were likely done by various assistants or later engravers. Only a small number are considered to have been executed by Marcantonio himself. For example, the first state of *Portrait of Pietro Aretino* (B.513), a work from the artist's mature years in Rome around 1520, includes an inscription dedicated to the sitter. In the second state, Marcantonio added four lines to the inscription, evoking the skill of the unnamed artist whose painted portrait was the source for the engraving.[9]

Pen-and-ink additions on a unique first-state impression of *Reconciliation of Minerva and Cupid* (B.393), in the collection of the Stanford University Museum of Art,[10] offer the only extant evidence of the way Marcantonio worked on a proof, namely by adding to it, not subtracting from it.[11] The additions are quite minor, involving various hatching lines that augment the modeling of the figures, as well as short, curved lines that define small undulations in the foreground. Marcantonio also added emphasis to already well worked areas, such as the trees and especially their knotholes.[12]

Rather than reworking the plate to effect changes in an image, Marcantonio sometimes made multiple, individual engravings of the same subject.[13]

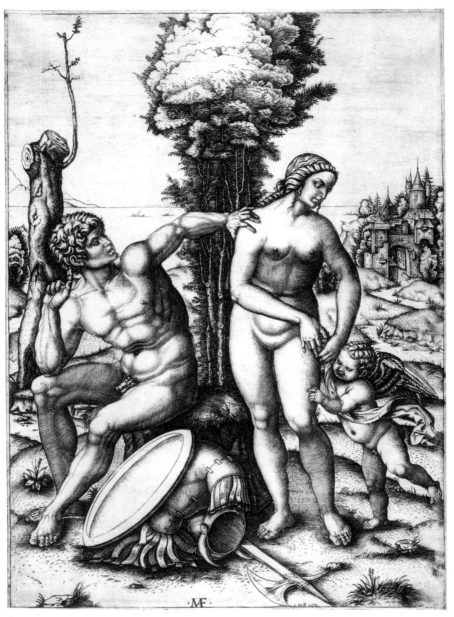

fig. 7

Marcantonio Raimondi, Mars, Venus, and Cupid, *1508. Engraving, 300 x 213;* B.345, *first state. The British Museum, London* [cat. 1]

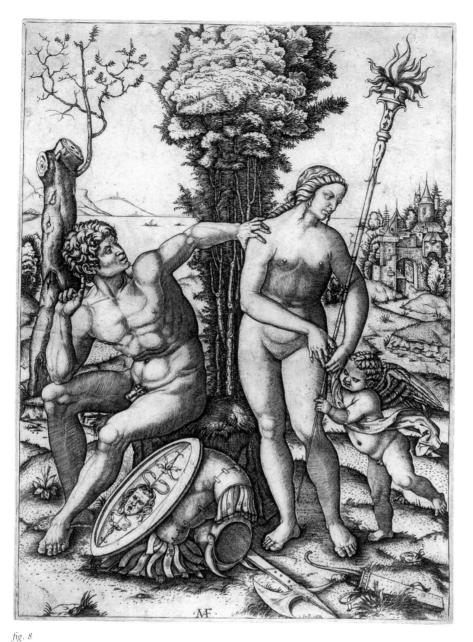

fig. 8

Marcantonio Raimondi, Mars, Venus, and Cupid, *1508. Engraving, 301 x 212;* B.345, *second state. Yale University Art Gallery. Gift of the Associates in Fine Arts. 1941.183.* The second state adds the torch and its staff, the quiver at the lower right, the Medusa on the shield, the three rivets to the axe, extra branches to the tree stump, and a few minor touches to the landscape. [cat. 2]

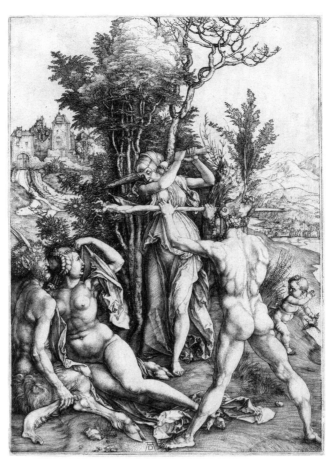

fig. 9

Albrecht Dürer, The Combat of Virtue and Pleasure in the Presence of
Hercules, *1498–99. Engraving, 324 x 225; B.73. Yale University Art Gallery.
The Fritz Achelis Memorial Collection. Gift of Frederick George Achelis, B.A.
1907. 1925.14* [cat. 3]

A confusing example is the *Massacre of the Innocents* (B.18 and 20; figs. 20, 21).
In this case, two individual plates of the same subject resulted in almost
identical engravings.[14] The major difference between the two consists of the
omission of a small pine tree in the upper right corner, replaced in the second
version by a deciduous tree. There are other subtle alterations as well, includ-
ing to the inscription on the dado.[15] Uncertainty over attribution abounds,
though both engravings are likely the work of Marcantonio.[16] Some scholars
have argued that he engraved the second plate when the first one wore out,
in order to further proliferate impressions of this popular work.

The more dramatic changes in the second version of Marcantonio's *Pietà* (B.34 and 35) signal the evolution of his mature style. In the earlier version of this print (ca. 1512), the Madonna's right arm is bare, true to the Raphael drawing in the Louvre on which it was based. In the later, more expressive version (roughly contemporary with the second version of the *Massacre,* ca. 1515), her arm is clad and she is wreathed by a more splendid halo. A dead tree is prominent in the middle ground, and the background landscape is quite different. Marcantonio also added more clouds as well as the blank tablet that appears as an identifying device in many of his mature works. The most striking change, however, is the transformation of the young, empty, ghost-like face of the first Virgin into the old, tortured, and poignantly modeled face of the Virgin in the second version.

Such evidence of the limited ways in which Marcantonio reworked his images suggests that he may not, in fact, have been responsible for the second state of *Mars, Venus, and Cupid,* with its more significant changes. The possible attribution of the second state to a later engraver, however, does not preclude the theory that the goal of the four altered impressions on parchment was to capture the look of an early, experimental proof. Furthermore, this paper assumes that whoever was responsible for the parchment impressions — likely a printer, engraver, or publisher — was not even aware of the first state of *Mars, Venus, and Cupid,* which must have been printed in a very small number of examples. He was thus only seeking to produce generic "early proofs" rather than return to a specific, known model.

On Yale's impression, the monogram, date, and flame of Venus's torch were deleted by scraping the parchment sheet to remove the ink (fig. 1; front and back cover). The Hill-Stone impression exhibits the most radical alterations: prior to printing, templates were used to mask the entire figure of Cupid as well as the Medusa head and the shaft, torch, and flame of Venus's staff (fig. 2). Likewise, the Medusa head, torch, flame, and some of the shaft were masked on both the Spencer and Zerner impressions (figs. 3, 4), and Marcantonio's monogram and date were scraped from the latter.

Further consideration of the Medusa-head decoration lends support to the hypothesis that the parchment impressions were intended as curiosities. Shields in general, either blank or decorated with a head, are common in classicizing art.[17] The shield, of course, is one of Mars's attributes, but whether it is decorated or blank does not necessarily affect the reading of a scene's

iconography. In the case of *Mars, Venus, and Cupid,* for instance, the head of Medusa, versus a more generic decoration *all'antica,* adds nothing to the iconographic program.[18] But as previously noted, the blankness of the shield in the first state seems unusually flat, resulting in an unfinished look. Such blankness in one of the parchment "proofs" would have insinuated that it was an early state or artist's proof, one that may have had particular appeal to collectors.

It is difficult, if not impossible, to date these parchment impressions of *Mars, Venus, and Cupid.* Even if we were to assume that Marcantonio made the second-state additions soon after completing the first state in December 1508, the dating of extant impressions of the second state is itself problematic. About a dozen paper impressions in American collections have been examined, and the conclusions they yield are hardly unequivocal. All of these second-state impressions—including Yale's (fig. 8)—are considerably inferior to the three known impressions of the first state. The plate had obviously experienced considerable wear between states. Whether that wear occurred over a few months, years, or decades is not clear. Optimally, one of these paper impressions would provide a watermark that might indicate a probable date, but current investigations have not been particularly conclusive. Two second-state impressions (at Yale and the Metropolitan Museum of Art) appear to carry the same watermark, a fairly schematic oak tree in a circle, but there is no consensus in the literature as to the usage of such paper. Briquet reproduces a similar watermark (no. 773) and firmly dates it to Rome, 1510–12. Such a date would be most convenient. Nevertheless, David Woodward and Aurelio Zonghi found an even closer watermark in use in Italian maps and other documents at mid-century and later.[19] Their findings may be more convincing, but alas, one can draw no firm conclusions.

Careful examination of the various signs of plate wear, however, provides some indication of the relative position of the parchment impressions among all the various paper impressions. Blemishes, scratches, and other flaws that occur in many impressions of the second state are completely absent from the "cleaner" impressions of the first state. One of the most prominent flaws occurs in *every* second-state impression we have examined: an uneven, broad mark that begins about fifteen centimeters down the left edge of the image and continues toward the right, through Mars's abdomen, and, in some dark impressions, into Venus's thighs. Under magnification, it is clear that this

smudged passage is indeed printed, and that it must have resulted from a broad abrasion or dent in the plate. This mark also occurs in all four of the parchment impressions. Many other scratches are shared by the paper and parchment impressions as well, including the small spot on the quiver and a faint, small circle in the sky near the upper left margin.[20] The only noticeable distinction between the paper and parchment impressions is a fairly light, diagonal scratch from upper right to lower left in the vicinity of Venus's forehead on all the parchment impressions, but on only one of the paper impressions examined thus far.[21] One would have to conclude that the parchment images were pulled from a plate whose condition was virtually the same as when it printed the examined paper impressions. Given the evidence of the watermarks, a date towards the middle of the sixteenth century, at the earliest, would thus best accommodate not only the second states of *Mars, Venus, and Cupid* in this exhibition, but those examined elsewhere as well.[22]

Zerner originally assigned his altered impression of *Mars, Venus, and Cupid* to the enigmatic print culture of the early sixteenth century, a culture with its "own connoisseurs," but he has more recently mentioned the possibility of a later date, nearer the end of the century.[23] Vasari reports that during the Sack of Rome in 1527, the German *Landsknechts* carried off Marcantonio's plates of non-Raphael subjects (which would include the present image).[24] This reinforces the likelihood that the plate for *Mars, Venus, and Cupid* survived and continued to be printed after Marcantonio's death around 1534.

One potential clue to the dating of the second-state impressions lies in the still unresolved significance of the FESZ monogram or "housemark" added to Mars's cuirass (fig. 1a).[25] Possibly it is the mark of the craftsman responsible for designing the armor itself.[26] But the letters might also represent a publisher's mark or device of some sort. There were at least two publishers in the sixteenth century whose names could have generated this particular monogram: Francesco Zilletti and Francesco Zanetti (F[ranc]ES[co] Z[...]). But as they were publishing in Rome near the *end* of the century,[27] any firm identification of this monogram as theirs is questionable. We must therefore concede that in order for this evidence to have any weight, the possibility of Marcantonio's not having executed the second state must be left open.

As previously noted, the alterations to the parchment impressions were achieved using two methods. The first involved scraping the parchment to remove parts of the already printed image and then rubbing to smooth the

scraped areas. The second involved masking specific areas of the copper plate so that no ink would be deposited onto the parchment. Only the first technique was used on the Yale impression; and although the monogram, date, and torch flame were systematically scraped with a metal blade and then rubbed to a smooth finish with a pumice stone or similar abrasive, they are still partially visible.[28] The second technique, which allowed complete occlusion, was used on the Hill-Stone and Spencer impressions. The former exhibits the most dramatic alterations: the areas of the plate containing the Medusa head, the entire figure of Cupid, and the staff, torch, and flame were masked and thus did not print. Only the Medusa head and the torch and flame, including some of the shaft, were masked in the Spencer impression. Both methods of alteration were employed in the Zerner parchment: the Medusa head and the flame, torch, and part of the shaft were masked out, whereas the monogram and date were removed — as in the Yale impression — by scraping off the printed ink.

The only alternatives to scraping and masking would have involved working on the plate itself. The ink could have been removed from the undesired areas of the plate, yielding a blind impression (i.e., without ink). Or, the engraved surface could have been permanently changed by burnishing out the undesired areas. The first method would not have been particularly successful, as it would have left traces of the uninked lines. The second notion of burnishing is implausible, because whoever owned the plate wanted to continue publishing prints from it for profit. Burnishing would have destroyed the plate's earning potential. Moreover, it might be argued that if the goal were to create "proofs" — a rarity in terms of this print — proliferation of impressions of the bona fide second state would have raised the value of the scarcer "proofs."

Examination of the Yale and Zerner impressions under ultraviolet light and microscopic magnification confirmed that both parchment sheets had been manipulated by scraping and rubbing after they were printed. The torch on the former remains the most visible of these incompletely erased areas. What appears to the naked eye to be a general faintness is revealed under the microscope as an area of unintentional pointillist tone (cover). Under magnification, printed ink lines normally look like heavy, jagged mountain ranges, sitting prominently atop the surface of the paper or parchment support (fig. 16). But in the scraped and rubbed areas, only small

amounts of ink in the pores of the parchment remain, resulting in the stippled effect. The depth of the ink within these pores — deeper than in other areas — indicates both that the plate had been heavily inked and, more importantly, that the scraping and rubbing process actually pushed the surface ink into the pores. The rubbing also resulted in a noticeable puckering of the parchment that, in the area of the torch, stretched the skin and formed a shallow crater.[29]

Also visible in both impressions, particularly where the date and monogram were scraped away, are saturated, oily areas that contrast with the unprinted, whitish, raised, and fibrous surface of the originally prepared skin.[30] Such remnants of the oily component of printing ink were apparently ineradicable, despite all traces of the black pigment having been successfully removed.[31] Their presence proves beyond any doubt that the monogram and date were originally printed and then manually expunged.[32]

Why would someone have taken pains to remove parts or all of the monogram and date from this print? Unfortunately, no single explanation seems totally convincing; but if these impressions were meant to look unfinished, the absence of a monogram would have been appropriate. It should be noted that scraping was used to erase all or some portion of the date on at least three *paper* impressions of *Mars, Venus, and Cupid* as well.[33] In the impression from the Davison Art Center (cat. 10), the date has been entirely scraped away, taking the borderline with it. At some point, the borderline was replaced, drawn in pen and ink.[34] When the erasure and pen work occurred is difficult to say, and the provenance of the object, like that of so many print impressions, is only partially known.[35] The other known scraped impressions on paper are in the collection of the Metropolitan Museum of Art. The year has been partially scraped and the 16D completely eliminated from the first of these (fig. 10), which also exhibits a few areas of pen-and-ink retouching just under Mars's buttocks, likely to cure faint printing.[36] On the second Metropolitan impression, the entire date is missing and, as in the Davison impression, the borderline has been redrawn in pen and ink (fig. 11).

While it is not possible to date the parchment impressions with any precision, one may speculate about the order in which they were printed. Clearly, they are sequential, experimental test impressions created in an effort to perfect a final version, or perhaps even a few final versions, which would have been marketed as proofs anticipating the second state. I believe that the Yale parchment was printed first. It is an unevenly trimmed impression but is

fig. 10

Detail of Marcantonio Raimondi, Mars, Venus, and Cupid, *1508. Engraving, 296 x 207; B.345, second state. The Metropolitan Museum of Art. Gift of Henry Walters, 1917.* The date and monogram have been partially obliterated by scraping the paper. [cat. 8]

in overall good condition, with only minor stains and some cockling.[37] The sheet itself is a fairly high grade of goatskin, being thinner and more pristine than the other three sheets, which are from the same species.[38] In regard to the alterations, the scraping worked well enough to remove the date and monogram, but it was not as effective with the flame and torch. Consequently, another method had to be invented, occurring for the first time in the Hill–Stone impression.

The masking technique involved in the Hill–Stone impression resulted in one of the most peculiar impressions of any old master print of the period. The templates were fashioned from a thin sheet of paper, possibly cut from a discarded impression to fit the given passages.[39] With the Hill–Stone impression, this method was pushed to its limit in the attempt to completely eclipse the figure of Cupid (fig. 2a). Since no iconographic justification exists for eliminating Cupid, one has to assume that this was simply an experiment to test the effectiveness of the masking method. In fact, the printer used as many as four separate templates in what was still a trial impression. As is common in experimental processes, problems emerged that demanded further exploration. The most obvious anomaly was the improbable look of the blank area left by

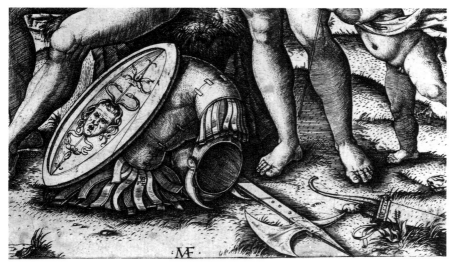

fig. 11

Detail of Marcantonio Raimondi, Mars, Venus, and Cupid, *1508. Engraving, 289 x 208; B.345, second state. The Metropolitan Museum of Art. Rogers Fund, 1918.* The entire date has now been eliminated by scraping the sheet of paper, but the borderline has been restored in pen and ink (presumably at a later date). [cat. 9]

the perfectly masked Cupid. This was obviously too much of a good thing. The torch area was also awkwardly over-masked. And the template on Mars's shield failed to cover the proper area, somehow slipping a couple of millimeters to the left before printing (fig. 2b).[40]

The Spencer impression followed as an attempt to solve the slippage problem. To keep the shield template in place, the printer seems to have applied an extra dollop of ink, after the plate had been inked and wiped, in order to adhere the mask to the plate. Visible all around the oblong masked area, and most apparent at the top of the shield, are marks of ink that were squeezed out from behind the template during the printing process (fig. 3b). The masking is also problematic in the torch region, where the templates must have been applied rather hastily, for the shape of the torch template is jagged (fig. 3a), and others overlap the borderline and even a bit of the tree. Obviously the immediate issue was the adhesion of the templates, not their shapes.

The final experiments occurred in the Zerner impression, which alone employed both the scraping and masking methods to make changes to the image. The monogram and date — the areas most easily deleted by tedious scraping — have been removed as in the Yale parchment. But in the areas

requiring a more sophisticated and skilled deletion technique, like the torch and the shield, the printer used the template method. This time the templates performed most successfully, without either slippage or seepage (fig. 4b). The staff of the torch, however, was allowed to print, because it overlaps Venus and could not be convincingly effaced (fig. 4a).

The position of the Yale parchment as the first of the series, however, is precarious. Of the four, it is the best sheet of parchment, suggesting that the printer hoped for good initial results. But because the alterations failed, subsequent experiments were undertaken on skins of lesser quality. The Zerner impression, which employs both techniques, is the most consolidated image and thus may be the last of the four. That it was a truly finished object is doubtful though, because it is on a poor sheet of parchment, a recycled document in fact. As there is, to the best of our knowledge, no complete, altered impression on a fine sheet of parchment, we might conclude that the printer considered the campaign unsuccessful and hence abandoned it.

One could argue that it would have been unlikely for parchment to be used as a test proof support because of its expense. But as is clear from comparison with the three altered paper impressions, parchment is the only support from which one could vigorously attempt to remove printing ink without severely damaging the object. Furthermore, as parchment was a commodity associated with specially dedicated manuscripts, books, and works of art, the printer may have had a patron in mind when he undertook our four impressions. One thinks, for example, of Titian's woodcut portrait of Ludovico Ariosto for the 1532 Ferrara edition of the *Orlando Furioso:* four presentation copies were printed on vellum.[41] Lilian Armstrong has also shown that numbers of North Italian incunables (books printed before 1500) were not only hand illuminated, but were printed on vellum, the quires of which had already been inscribed with the patrons' names.[42]

The rather low quality parchment employed for our proofs could have been obtained quite affordably, as it turns out. In 1550, Nicolas Mameranus mentions monasteries selling parchment documents for scrap, presumably for reuse.[43] The Zerner impression is printed on the verso of just such a manuscript document, containing a passage in Latin in what appears to be a late-fifteenth-century hand.[44] That this text—now almost illegible because the sheet had been glued onto a wooden panel—is truncated, is evidence that the sheet served as a vehicle for the text before it was used for the print.[45]

Another altered impression on parchment, this one of an engraving by Marco Dente da Ravenna, is in the collection of Randal H. Keynes of London (fig. 5). Generally regarded as coming from an almost completely reworked plate of Marco Dente's *Virgin of the Fish,* more formally known as the *Virgin and Child with Tobias and the Angel and St. Jerome* (figs. 12, 13), it is the only one known to us that exhibits a similar use of templates to mask the printing of certain areas. On the righthand side, the figures of St. Jerome and the lion have been entirely masked, with the exception of a tiny bit of the lion's paw. Significantly, a false Marcantonio tablet as well as the address of the publisher Antonio Salamanca—which appears at the lower left in other impressions of the reworked plate—have been masked out as well.[46] Salamanca owned and published impressions from many plates, including those of Marcantonio and Marco Dente, but one would have to imagine that this impression was made after the plate had left Salamanca's possession, possibly after 1554, when he turned his stock and plates over to Antonio Lafrery.

The Keynes impression is also printed on a recycled manuscript document. In this case, the writing appears on both sides: faintly on the recto, where it was scraped away—perhaps in preparation for the printing of the Marco Dente—and more visibly on the verso. The traces remaining there indicate that it was originally a Curial document from Rome of the late fifteenth or early sixteenth century.[47] As the Keynes parchment has only recently come to light, it has not yet been fully studied and cannot be definitively related to the campaign that is the subject of this study. But the fact that it was not only printed on parchment—so rarely encountered in sixteenth-century Italian printmaking—but was likewise partially masked with templates, suggests that it is another piece in a fascinating puzzle that may one day yield a plausible solution.[48]

The answers are still uncertain. We know only that a campaign occurred and that it failed to produce convincing results, at least as evidenced in the extant impressions. We must assume that proofs were indeed collectible, as one has only to think of the two famous unfinished proofs (on paper) of Albrecht Dürer's 1504 *Adam and Eve* in Vienna (Graphische Sammlung Albertina). In fact, the early seventeenth-century artist and collector Peter Lely owned the paper proof impression of Marcantonio's *Apollo on Parnassus,* which is part of our exhibition (fig. 18).

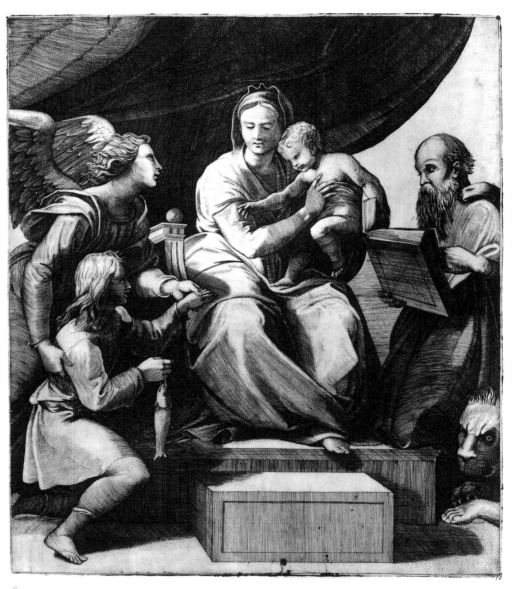

fig. 12

Marco Dente da Ravenna, Virgin and Child with Tobias and the Angel and St. Jerome. *Engraving, 263 x 219; B.XIV.61.54, first state. The Metropolitan Museum of Art. Gift of Henry Walters, by exchange, 1931* [cat. 11]

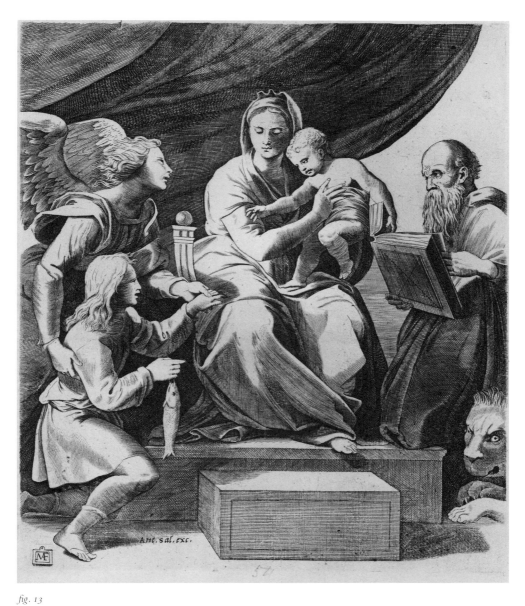

fig. 13

Marco Dente da Ravenna, Virgin and Child with Tobias and the Angel and St. Jerome, *ca. 1540−50. Engraving, 257 x 217; B.XIV.61.54, second state with address of A. Salamanca and false Marcantonio monogram. The Metropolitan Museum of Art. Gift of Michel Benisovitch, 1930* [cat. 12]

If these objects were experiments meant to result in convincing proof impressions of *Mars, Venus, and Cupid,* one inevitably queries their appearance on parchment. With few exceptions, single prints were almost never printed on parchment in the sixteenth century. While it seems likely that parchment would aid in creating an item of richness and rarity, its material strength facilitated the manipulation of the images by scraping, no matter how unsuccessful it proved in the long run. The mere survival of these four aberrant parchment impressions of *Mars, Venus, and Cupid* indicates that they must have been valued as collectible and puzzling curiosities if not thought of as actual proofs for this print. Only as more impressions of *Mars, Venus, and Cupid* undergo this kind of extensive scientific and art historical examination might these elusive but intriguing artifacts yield answers to our questions about their date and usage.

1. Adam Bartsch, *Le Peintre graveur,* 21 vols. (Vienna, 1803–21); hereafter abbreviated B.

2. Henri Zerner, "A propos de faux Marcantoine. Notes sur les Amateurs d'estampes à la Renaissance," *Bibliothéque d'humanisme et de la renaissance* 22 (1961): 477–81.

3. Innis H. Shoemaker and Elizabeth Broun, *The Engravings of Marcantonio Raimondi* (Lawrence, KS: The Spencer Museum of Art, 1981), 76–79. Their observation that "although imperfectly printed, [the Yale impression] shows no evidence of alteration of the engraving's final state" (78) was unfortunately based on a photograph of Yale's *other* impression of the print—this one on paper (fig. 8) — which was accidentally switched for the one on parchment and illustrated as fig. 13d, p. 79.

4. This meaning of the monogram comes from Vasari, who suggested that "Marcantonio de'Franci" stems from the surname Marcantonio acquired from his teacher, the Bolognese goldsmith Francesco Raibolini, called "il Francia." It might also stand for "Marcantonio Fecit," perhaps an equally plausible meaning for the acronym.

5. The reading of this apparent monogram stems from Bartsch, with whom I concur about the letters and their order. This at first seems to read FZ, but the ES clearly is attached to the F, and thus one assumes follows it. The monogram is difficult to read in most impressions.

6. See the convincing argument by Wendy Stedman Sheard, *Antiquity in the Renaissance* (Northampton, MA: Smith College Museum of Art, 1979), 56.

7. In addition to heeding northern influences, Marcantonio was of course greatly affected by such Italian predecessors and contemporaries as Andrea Mantegna and his student, Giulio Campagnola. In fact, *Mars, Venus, and Cupid* was once thought to be based upon a lost drawing by Mantegna.

8. See David Landau and Peter Parshall, *The Renaissance Print, 1470–1550* (New Haven: Yale University Press, 1994), 122.

9. Shoemaker and Broun, 150, suggest the interesting connection of this engraving with the later Arezzo portrait of Pietro by Sebastiano del Piombo, suggesting that both may have been based on a similar source.

10. Committee for Art Fund, 1969.20; see Lorenz Eitner et al., *The Drawing Collection, Stanford University Museum of Art* (Seattle: University of Washington Press, 1993), 10–13, no. 17. There is also a pen-and-ink drawing on the verso of this impression.

11. Shoemaker has persuasively argued that this is indeed the pen work of Marcantonio, since the lines added on the working proof are consistent with those ultimately engraved into the plate; see Shoemaker and Broun, 142.

12. The ambiguous word "carsi" is also added in pen and ink. Alessandro Nova postulates that it is an abbreviation for "caritas," or charity. Ibid., 12.

13. Such a process was often performed when one plate was worn out in order to further proliferate impressions of the same subject.

14. Two states of the first version exist; the first state has no inscription, while the second state does. There is also some uncertainty as to which version actually came first, but Bartsch's chronology is quite reasonable.

15. For example, the rare second state of the first version spells Raphael's name "Raph" whereas it is "Rapha" in the second version. Also, the monogram in the second state of the first versions is just MA whereas it is MAF in the second version. These minor differences are all discussed in Bartsch.

16. For a summary of the attribution debate, see Shoemaker and Broun, 108.

17. A famous painted example, which may have been roughly contemporary with the time of the additions in the second state, is in Raphael's *School of Athens*. (Though in this case, the shield with the head is not round.)

18. There are many visual precedents for shields decorated with the apotropaic head of Medusa. For example, a nearly identical Medusa-head shield (together with a totally blank one) appears in Jacopo de' Barbari's *Victory,* which dates around 1500 (B.VII.526.23). One can also see a Medusa-like shield in Giulio Bonasone's *Calypso Attempting to Detain Ulysses* (B.XV.154.171); an exquisite and unique working proof of this engraving, printed in red ink, is included in this exhibition (fig. 6). In this case, however, Susan Matheson has identified the snakeskin background as signifying the "shield" of Athena, who came to

Odysseus's aid during his encounters with Poseidon and other unhappy gods. Marcantonio himself made various use of the Medusa motif, as in *Judgment of Paris* (B.197.245; cat. 24), where it is obscurely positioned and foreshortened in the center foreground, leaning upon a helmet, as well as in *Athena* (B.XIV.253.337).

19. David Woodward, *Catalogue of Watermarks in Italian Printed Maps, circa 1540–1600* (Biblioteca di Bibliografia Italiana 141, 1996), 86–87, nos. 126–28. Also see Aurelio Zonghi in *Monumenta Chartae Papyraceae Historiam Illustrantia* 3 (Hilversum, Holland, 1953), 124, no. 1733.

20. It is present approximately 4.5 cm down from the top left corner, tangential to the borderline.

21. Veste Coburg.

22. There are many other little lines and marks, which appear during the lives of most copper plates. For example, in the shield there is a faint line running horizontally at the top. It is clearly inked and visible when viewed under high magnification, but almost always undetectable in reproductions. Many of these lines are so light that they can actually disappear because the pressure of printing gradually closes up and polishes such flaws. In some cases, of course, plates have been re-engraved and damaged areas burnished to smooth out such blemishes so that they no longer hold ink.

23. Zerner, 481; Zerner recently mentioned to me that he now thinks the campaign could have been as late as the early seventeenth century.

24. Landau follows Vasari and postulates that the Germans availed themselves of Marcantonio's own cache of plates rather than those held by Raphael's publisher, il Baviera.

25. Although Bartsch duly noted the addition of the letters, he questioned whether they meant anything at all.

26. See Shoemaker and Broun, 78. That suggestion raises an interesting possibility: that the monogram refers to Marcantonio's teacher, Francesco Francia (F[ranc]ES[co il fran]Z[a]), who was not only a printmaker but a goldsmith as well. But there are no recorded instances of Francia signing his work with a "z" instead of a "c."

27. Both were book publishers; see Bruno Giglio, *Incunaboli Cinquecentine* 2 (Ivrea: Bolognino Editore, 1989), 768. The book is a 1584 *Fructus*

Admirabiles of Giulio Fulci, no. 199. Ziletti is no. 243.

28. I originally thought these areas had only been rubbed, as they are very smooth and exhibit none of the characteristic marks one is used to seeing when parchment is scraped with a sharp instrument. However, Abigail Quandt, a conservator at the Walters Art Gallery in Baltimore, Maryland, and an expert on parchment and vellum, is confident that these areas have indeed been scraped. The use of volcanic pumice as an abrasive to smooth parchment and vellum surfaces is discussed by Richard Bigus in Decherd Turner et al., *The Mystique of Vellum* (Boston: Bromer Booksellers, Inc., 1984), 27.

29. That the borderline is not visible in that area is due to the close trimming of the edge, not erasure.

30. The unprinted areas also have a whitish appearance as a result of calcite grounds used to prepare the surface. See Theresa Fairbanks's essay in this catalogue.

31. For more on the makeup of ink in the Renaissance, see Fairbanks's essay, and C. H. Bloy, *History of Printing Ink, 1440–1850* (New York: Sandstone, 1967), 97 and passim.

32. Additional evidence supporting the occurrence of the scraping and rubbing process is the relative absence of the tiny hair fibers that are still present in the non-scraped and non-rubbed areas. These hairs, which can be clearly viewed under the microscope, are absent in the three key areas in question, those of the monogram, date, and torch flame.

33. It is impossible that the areas were simply damaged, owing to the precision and method of the deletions. An example of a damaged impression on paper is found in the Philadelphia Museum of Art. The abraded area is just above the date, beneath the curvature of the axe head. The missing lines again have been drawn in pen and ink. The abrasion undoubtedly resulted from an attempt to remove a foreign substance or stain and has no relation to any campaign to eradicate the date and monogram.

34. A small hole (1 x 1.5 mm) can be detected, even in reproduction, at the right of the erased area. The new ink is of a slightly bluer hue and is less glossy. The line itself is thinner and cleaner at the edges.

35. There is a collector's mark belonging to K. E. Hasse (1810–1902), reproduced in Frits Lugt, *Les Marques de Collections* (Amsterdam, 1921), no. 860. Hasse used two marks in sequence during his collecting years, this one being the later and more common of the two.

36. Gift of Henry Walters, 1917; 17.37.302. It is this impression that is printed on paper with a watermark that is very likely identical to the one found on Yale's paper impression.

37. The fact that it is uneven might suggest that it came from the very edge of a parchment skin, although it is of course possible that the edge was damaged or accidentally cut too far at some point by an owner.

38. I am grateful to Theresa Fairbanks and Abigail Quandt for determining that these sheets are goatskin.

39. The Hill-Stone impression contains traces of paper, which are apparent under about 10x magnification, in the masked areas, especially along the torch shaft. The paper must have adhered to some extent due to the extreme pressure of the printing process.

40. See the previous note on the Hill-Stone impression regarding adhesion during printing. The template could not have slipped once the plate and parchment were under the platen.

41. Pierpont Morgan Library; 800/E-2/46/B.

42. "Problems of Decoration and Provenance of Incunables Illuminated by North Italian Miniaturists," *Papers of the Bibliographic Society of America* 91 (1997): 476. This would obviously have been the case with fine sheets and not those such as palimpsests, which were recycled for many uses.

43. Paschasius Radbertus, *De corpore et sanguine Domini* (Cologne, 1550). Robert G. Babcock mentions this in "Manuscripts of Classical Authors in the Bindings of Sixteenth-Century Venetian Books," *Scrittura e Civiltà* 18 (1994): 319 n.17. See Karl Schottenloher, "Handschriftenforschung und Buchdruck im XV. und XVI Jahrhundert," *Gutenberg Jahrbuch* (1931): 94 n.2 for a transcription of Mameranus's comments.

44. I am grateful to Robert Babcock of the Beinecke Rare Book and Manuscript Library, for assisting me with the reading of the back of the Zerner impression.

45. The wood grain impression from the panel is still visible in the adhesive and skin under ultraviolet light. David Rosand and Michelangelo Muraro discuss how some woodcuts were pasted to doors and paneling from the fifteenth century into the seventeenth century, as can be seen in Dutch interiors (*Titian and the Venetian Woodcut* [Washinton, DC: International Exhibitions Foundation, 1976], 10, 19).

46. In discussing this reworked version of Marco Dente's original engraving, Bartsch notes that some had only the Salamanca address: "on a des épreuves de cette planche retouchée qui portent l'adresse: Ant. Sal. exc. écrite vers la gauche d'en bas" (B.XIV.63).

47. The writing on the verso includes, along with a very typical end of a Curial document executed in Rome, four signatures of Spanish and Italian men. The names have not yet been compared with Church records in an attempt at dating.

48. I know of only one other impression of an engraving on parchment that is datable to the sixteenth century, that of a *Portrait of Aldus Manutius* in the National Gallery of Art, Washington. A very odd *Bacchanalian Scene* (Cleveland Museum of Art) on two sheets of parchment pasted together, once attributed to Marcantonio, is clearly not his work, and it is likely that this impression is much later than the sixteenth century. There are woodcut impressions from the sixteenth century on parchment, such as a copy after Titian's *Six Saints,* in the Museum of Fine Arts, Boston (1975.494). In addition, books were often printed on parchment during this period.

The Mystery and Mystique of Printing on Parchment

HAMLET Is not parchment made of sheep-skins?
HORATIO Ay, my lord, and of calf-skins, too.
—William Shakespeare, *Hamlet* 5.1.114–15

THERESA FAIRBANKS

THE PURPOSE OF THIS ESSAY is to describe the extraordinary nature of parchment and its accommodation to copperplate printing. The essay will focus on the use of parchment as a support for engravings by the Renaissance master Marcantonio Raimondi, in particular his *Mars, Venus, and Cupid,* dated 1508.

HISTORY OF PARCHMENT

There is an aura surrounding the word parchment, which is broadly — and mistakenly — applied to a wide range of materials used by printmakers, calligraphers, illuminators, graphic designers, architects, stationers, paper makers, bookbinders, and bakers. Today many of these professions actually use a paper-based material that only imitates the appearance of parchment.[1] But what is "real" parchment? According to its most basic definition, parchment is an animal pelt that has been dehaired (through treatment with enzymes or an alkaline lime solution) and then, while still damp, attached to a frame and dried. Parchment is not chemically tanned as is leather, in which a skin is treated with plant tannins that make it flexible and imputrescible. In parchment preparation, the shrinking of the pelt as it dries (under tension) reorganizes its collagen fiber network into a new, highly stressed condition. Only if the skin gets wet will it tend to revert to its original state.[2]

Parchment was one of the earliest materials (or supports) used for recording texts and images. Early skin remains are rare, but the *Dead Sea Scrolls* (which have been dated between 200 B.C. and 100 A.D.) are made of parchment.[3] Parchment also served as drum heads and sounding boxes of musical instruments such as tambourines. An Egyptian mandolin of the 18th Dynasty (about 1400 B.C.) was said to be covered with parchment made from gazelle skin.[4] Parchment was also transparentized with linseed oil for use as window coverings. In the first century A.D., Pliny perpetuated the story of the "invention" of parchment by King Eumenes II (197-159 B.C.) of Pergamum, near Smyrna in Asia Minor. The King was said to have invented it as a substitute for papyrus when the Egyptian Pharaoh (Ptolemy Epiphanies, 205–182 B.C.) forbade the export of papyrus in the hope of preventing the growth of the great library at Pergamum.[5] We have no conclusive proof that parchment was invented in Pergamum, but this type of prepared skin took its name from that city. More durable in damp climates, it eventually superseded papyrus, becoming the most common writing material in Europe around 400 A.D. Parchment was in turn gradually displaced by linen-based paper,[6] which was

introduced from the East in the early twelfth century.[7] After the middle of the fifteenth century, printing from movable type—developed principally by Johannes Gutenberg in Mainz—challenged the handwritten manuscript text, which traditionally employed parchment. The huge demand for both printed texts and images led to a rapid rise in the manufacture of paper, which was far cheaper and more adaptable to mechanical processes than parchment.

Goats, sheep, and calves most commonly provided the skins for European parchment.[8] Finer grades of parchment are often referred to as *vellum,* which is a confusing term. A strict definition requires that vellum be prepared from abortive or fetal animals referred to as uterine skins (generally calves, as they would be the only fetal/stillborn animals large enough to provide a reasonable size skin). Indeed, the word vellum likely originates in the Latin word "vel" for calf.[9] To quote a 1519 text, "That stouffe that we wrytte upon: & is made of beestis skynnes: is sometyme called parchment/somtyme velem/ sometyme membraan. Parchment of [for] the cyte [city]: where it was first made. Velem/because it is made of calvys skynne. Abortyve/because the beest was scante parfaits [i.e., was not perfect—therefore stillborn]. Membraan/ because it was pulled of by hyldynge from the bestis lymmes [i.e., members]."[10] For the purposes of this essay and exhibition, the authors have decided to use the more generic term parchment, as all vellum is parchment, but not all parchment is vellum.

Animal skins, whether parchment or vellum, were the writing materials of the Middle Ages. The velvety smoothness of well-prepared parchment made it ideal for manuscript texts and illuminations.[11] But with the invention of printing, parchment was largely reserved for special occasions, for presentational or luxurious volumes, or for projects that required its greater strength and durability. Books whose pages were handled and flexed frequently—for example, the Canon page of a Missal—were sometimes printed on both paper and parchment. It is of pointed significance that twelve of the thirty copies of the Gutenberg Bible (1461) printed on parchment have survived, but only thirty-five of the 150 copies printed on paper are extant. Documents of all kinds continued to be printed on parchment (as they are still), and occasionally, single engravings and woodcuts were printed on it.[12] But by 1508, when Marcantonio engraved *Mars, Venus, and Cupid,* paper had all but replaced parchment as the preferred support for prints. Accordingly, this exhibition, which brings together five sixteenth-century intaglio impressions on parchment, must come to grips with such an unexpected use of parchment.

Preparation of parchment differed according to geographical area and century, but was always a complicated and time-consuming process (fig. 14). The skins were first washed in clear water. The first stage of processing involved softening the epidermis and removing the hair. In the Middle East, this was done through the natural agents of decay ("sweating") and the introduction of bacterial enzymatic solutions, created by fermenting grains, flour, oak galls, and dung. In Europe, slaked lime baths were principally used for the dehairing process. The parchment on which the prints in this exhibition were executed was probably given a lime bath (30% freshly slaked lime) for eight to sixteen days depending on air temperature.[13] The lime solution swelled and weakened the hairs, facilitating their removal. The lime also dissolved the nonfibrous collagen materials in the skin. The hair, and remnants of fat and flesh, were scraped away with a blunt knife, and the skin was soaked again in a fresh lime bath, washed once more, and lashed onto a frame for several weeks (fig. 15). Each skin was scraped and dampened repeatedly to remove limewater, liquid collagen, and other unwanted materials. As the skin dried on the frame it would shrink, tensioning itself. Additional tensioning adjustments could be made with the pegs or strings attached to the skin and the frame.

The dried skin was shaved with a very sharp, two-handled, crescent-shaped knife called a "lunallarium." This final scraping removed a very fine surface membrane and left the skin absolutely smooth. Further finishing depended on the parchment's intended use. Those employed for printing needed to be soft and flexible to conform to the surface of the metal type or plate. They may also have been slightly sanded with pumice to raise the nap and increase the attachment of applied materials such as pigments and printing inks. To make a very pure skin, additional degreasing was extensively practiced in Italy and France in the fourteenth and fifteenth centuries using a kind of thick paint made from calcite, chalk (forms of calcium carbonate), or other calcium salts such as gesso (calcium sulfate). The calcium compounds were painted on the damp, tensioned, and shaven skin to draw out and absorb water and grease. The extracted material was removed and the process was repeated as necessary. In addition to thinning the pelt, shaving helped to open up the pores to allow the paste mixture easier penetration of the skin. A final surface coating of fish or animal glue or egg white (glair) was sometimes used to size the skin.[14] These final preparations provided a smooth and whiter

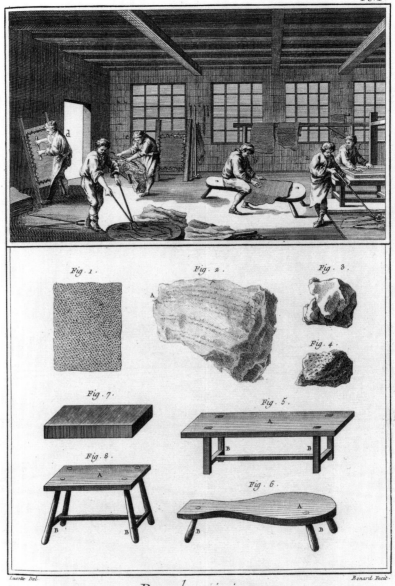

Parcheminier

fig. 14

Parcheminier (The Preparation of Parchment), from Denis Diderot, Recueil de Planches, sur Les Sciences, Les Arts Libéraux, et Les Arts Méchaniques, avec Leur Explication *(Paris: Michel Le Brelon, 1762–67); vol. VIII, pl. I, engraving. Photo courtesy Beinecke Rare Book and Manuscript Library, Yale University.* This plate illustrates all the stages of parchment making (although not in sequence). The pelts are: a) washed, b) pounced/scraped, and c) soaked in a bath of slaked lime. The skin is then d) lashed on a frame and scraped, e) the hair is scraped off, and finally f) the parchment is cut to size. The bottom half of the plate illustrates equipment and materials: 1) detail of parchment illustrating the interlaced fibers of the skin; 3) chalk/gypsum; 4) and 7) pouncing stones; 5), 6) and 8) tables and stools for pouncing/scraping.

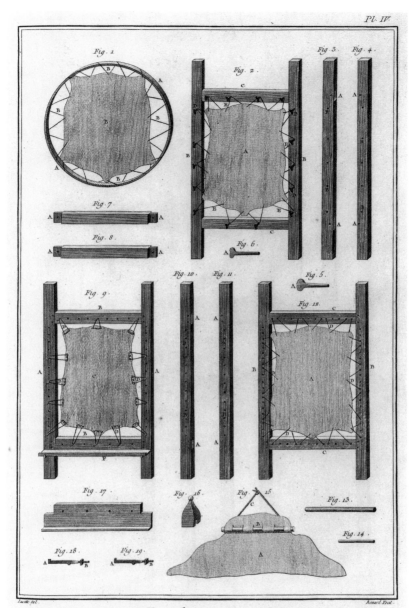

fig. 15

Parcheminier (The Preparation of Parchment), from Diderot, Recueil de Planches…, *vol.* VIII, *pl.* IV, *engraving. Photo courtesy Beinecke Rare Book and Manuscript Library, Yale University.* This plate illustrates three different types of parchment frames and three methods of attachment to the frames and tensioning.

surface better suited to printing ink. Evidence of such treatment is most clearly visible on the parchment impression of Marco Dente's *Virgin and Child with Tobias and the Angel and St. Jerome* in this exhibition (fig. 5a).

Drying under tension imparts a certain opacity to the parchment, whose color is affected by that of the animal's hair: the whitest skins come from those with white hair. In addition, treatment in the lime baths has a mild bleaching action, which lends a colder, bluer tonality to the skin than dehairing with enzymes, which creates a warmer, creamier hue.[15] The color of the skin could also be affected by the purity of the water used in processing. Stale, unfiltered water could result in a greenish tint.[16] It is of interest that the alkaline lime treatments have also added to parchment's longevity, as they help neutralize acid degradation caused by atmospheric pollution and poor storage conditions.

Printing on parchment is very different from printing on paper. Parchment's dense structure does not readily absorb printing ink, which stays on the surface of the skin. It was therefore considered preferable to use matte ink, as the glossy inks used in printing on paper would have sparkled distractingly on the nonabsorbent parchment.[17] Comparison of two impressions of *Mars, Venus, and Cupid*—one on parchment, the other on paper—shows that ink on parchment often had a fuzzier, more velvety appearance (fig. 16). Parchment was also notoriously difficult as a printing surface. Part of its fascination was the opalescent quality of its finish, but this could be lost in the printing process: one had to be careful when dampening the skin prior to printing, as too much moisture could render it transparent. After the emergence of paper, intaglio printmakers would have needed a special reason to use parchment. In antiquity, parchment had been preferred to papyrus in part because its surface could be reworked. If the scribe made a mistake, he could simply scrape away his error and start again. Extensive scraping was not possible on papyrus or early papers without noticeably damaging the surface. This fact may provide a clue as to why these four impressions of Marcantonio's *Mars, Venus, and Cupid* were printed on parchment. Two of the prints show design alterations that were accomplished in part by scraping the ink off the skin.

EXAMINATION AND TECHNICAL ANALYSIS

All five parchment prints in this exhibition—four impressions of Marcantonio's *Mars, Venus, and Cupid* and a single impression of Marco Dente's *Virgin*

fig. 16

Details of Mars, Venus, and Cupid *on paper (above) and parchment (below). Taken from the Yale impressions.* [cats. 2, 4]

and Child with Tobias and the Angel and St. Jerome — are on goatskin and were printed on the hair side of the skin, as can be determined by the distinctive pattern of hair follicles prominently evident on the image (recto) side of each skin (fig. 5a).[18] The skins vary in appearance and thickness, ranging from .17 to .44 millimeters. The surface of each of the Marcantonio parchments reveals evidence of having been prepared prior to printing with a white, inorganic material. Analysis by x-ray fluorescence (XRF) and Fourier Transform Infrared Reflectography (FTIR) identified these preparations as calcium compounds: principally calcite (calcium carbonate) in three of the four, and gypsum (calcium sulfate) with traces of calcite in the fourth.[19] These calcium-based

minerals were used to absorb the skin oils, whiten and unify the tonality of the skin, and fill in the grain in order to provide a better surface for printing. Depending on the thickness with which they were applied, they could also mask the more skin-like appearance of the parchment. Their use most likely evolved historically from the use of gesso grounds on panel paintings and similar preparatory grounds for drawings on paper.[20] The coatings were probably fairly uniform originally, imparting a smooth and luminous off-white appearance to the skins, but over time they have become uneven, largely due to mounting and unmounting.

As previously noted, these parchment impressions reveal alterations to the original design of the images. We do not know why the printers chose to modify the printing of the plates, but it may have been to create a print that looked like a "proof impression," a rarity intended to attract collectors. In Yale's impression of *Mars, Venus, and Cupid* (fig. 1; front and back cover), the top of the staff and flame as well as the monogram with the interconnected letters "MAF" and the date "1508 16D" (16D stands for the 16th day of December) have all been scraped away.[21] Both monogram and date have likewise been scraped from the Zerner impression (fig. 4b).[22] Such scraping would have been done after the ink had dried. Two additional changes to the design of the Zerner impression were created by masking areas of the plate with thin templates prior to printing: the Medusa head on the shield and the flames atop the staff. Templates likewise masked these areas on the Hill-Stone and Spencer parchment impressions of *Mars, Venus, and Cupid* (figs. 2, 3). It is all but certain that the persons making these prints wanted to experiment with the design without changing the plate itself.[23] Scraping the design off the skin and masking certain areas with templates would have been a much easier and faster method of working. Further, they may have chosen parchment rather than paper because the templates would cause less surface embossment of the thicker, denser skins.

The Zerner impression of *Mars, Venus, and Cupid* was printed on a reused parchment: fold marks (fig. 4a) and, on the verso, evidence of writing that has been removed by scraping (fig. 17) point to its former life as a fifteenth-century Latin document.[24] That it is the thickest of the five parchments (.38–.44 mm)—is consistent with such a history, as thicker skins (coming from older animals) were used for the production of documents so that they could withstand repeated folding and handling. Coarse and nonplanar because of the folds, the skin may have been difficult to print. Certainly the

fig. 17

Verso of Marcantonio Raimondi, Mars, Venus, and Cupid, *1508. Engraving printed on parchment with manuscript on verso, 290 x 202. Lent by Henri Zerner, Cambridge, MA* [cat. 7]

image has been poorly printed. The recto of the parchment has a distinct yellowish brown cast from a discolored organic coating that had been applied to the surface, perhaps at some later date. Technical analysis indicates that it may be a nondrying or semidrying oil with a small amount of a conifer (pine) resin.[25] It was probably applied to "lubricate" the skin in a desire to preserve and possibly flatten it. As parchment is notoriously reactive to climatic changes, buckling badly in unstable environments, it was sometimes brushed with oils — e.g., linseed oil — to produce a lustrous, flexible coating that inhibited the entry of water vapor.[26] The white pigment preparation on the Zerner impression has been totally obscured by this surface coating. Nevertheless,

analysis proved it to be principally gypsum (calcium sulfate) with a small amount of calcite, which were common materials used in the preparation of manuscript parchment.[27]

The Hill-Stone and Spencer impressions are both on thickish goatskins, probably denoting older animals (.22–.30 mm). It is not possible to determine whether they are from the same animal without doing more sophisticated analysis such as DNA testing.[28] In both, the top of the staff and flames as well as the Medusa head have been masked by templates. In the Hill-Stone impression, the figure of Cupid and the entire staff have been masked as well. Although the masking and printing of each impression are slightly different, they are similar enough to look as if they may have been printed by the same person. In fact, the masks for the shields in both impressions are exactly the same size, and the squarish/trapezoidal templates that mask the printing of the flames in both are quite similar in size and shape, although not identical.[29] Additionally, the color and translucency of both skins are very uneven: they are slightly brown and blotchy, and the white ground preparation is uneven. The versos of both indicate that they were previously backed with an adhesive and a board, which have largely been removed.[30] The backing and unbacking process undoubtedly involved moisture and pressure, which likely caused the mottling of the skin, varied translucency, and transparentizing of the white preparatory ground. The image passages that read best visually are those where there is still significant white calcite preparation to create an opaque backdrop for the black, carbon-based printing ink.[31]

Yale's impression is on the thinnest and finest quality goatskin: .17–.23 mm, with the scraped areas producing a slightly thinner skin. It is pale yellowish white, and the skin is relatively uniform, although there is a slight concavity in the flame area due to the pressure exerted in scraping. On the verso, there is a residue of a paper backing that has been almost entirely removed.[32] This backing would probably have been adhered with a water-based adhesive under pressure. Both the moisture and the pressure altered the appearance of the white calcite preparation, making it more transparent; it is barely visible except in the upper left quadrant. The lack of this opaque white ground narrows the contrast between the printing ink and the color and translucency of the parchment. Despite its condition, however, the Yale impression gives us a suggestion of the beauty and richness one could obtain by printing on parchment.

The parchment impression of Marco Dente's *Virgin and Child with Tobias and the Angel and St. Jerome* exhibits a similar use of templates to mask

the printing of design elements (fig. 5). It too is on recycled parchment, which is from the sixteenth century.[33] An earlier impression of the same plate on paper bears the print publisher Antonio Salamanca's inscription "Ant. Sal.exc." and a false "MAF" (Marcantonio Raimondi monogram) on a tablet,[34] indicating that Salamanca acquired the plate and had it re-engraved (fig. 13). At some later date, the parchment impression was printed, masking the Salamanca inscription, the Marcantonio tablet, and the figures of St. Jerome and the lion, possibly in a desire to return to the "original" Marco Dente plate. Little is known about Salamanca, who had a shop in Rome in the Campa dei Fiori by 1527. The earliest print that bears the inscription "Salamanca excudit" is 1538. The latest cited example of the Salamanca inscription occurs in 1554.[35]

Although none of the numerous impressions of *Mars, Venus, and Cupid* on paper shows any sign of masking with templates, several appear to have been slightly altered as well. Three of the second-state impressions on paper have been changed by scraping away all or part of the date (figs. 10, 11).[36] The paper impressions all appear to be printed on paper of the appropriate period, most with watermarks and visual characteristics of mid-sixteenth-century Italian paper, and a few with possibly later features.[37]

CONCLUSION

Although close examination and analysis reveal *how* these altered impressions on parchment were created, intriguing questions remain concerning the *when* and *why* of their production. What might account for the decision to employ a support whose manufacture was much more expensive and labor intensive than paper's? Why would one use parchment when it was considerably less receptive to printing ink? Its relatively hard, smooth surface did not readily absorb the black pigment, and its hard surface caused more wear to the copper printing plates than paper. Parchment did provide a material from which passages of the image could be fairly effectively effaced by scraping. And it certainly projected overtones of luxury and rarity, an aura of history and desirability that paper could not have.

Employment of parchment harks back to an earlier era, prior to the proliferation of handmade paper. Printing on parchment has been practiced periodically, if infrequently, throughout history. Books printed on parchment were made for deluxe examples with hand illuminations, as special presentation

editions, and as author copies. One thinks of *Biblia Latina* (Venice: Nicolau Jenson, 1476); Homer, *Opera* (Florence: Bernardus Nerlius, Nerius Nerlius, and Demetrius Damilas, 1488); Maximilian I, Melchior Pfintzing, and Marx Treitz-Saurwein, *Theuerdank* (Nuremberg: Hans Schönsperger, 1517); and Flavius Josephus, *L'histoire escripte premierement en Grec....contenant les guerres qui furent au pays de Judee* (Paris: N. Sautier for Gallio Du Pre...., 1530). The tradition extended through the nineteenth century, and William Morris's many publications for the Kelmscott Press come to mind. For Morris, moreover, parchment signaled the historical integrity of the Press and its "return" to the methods and materials of medieval craftsmanship. On the other hand, it is particularly difficult to locate parchment impressions of individual prints during the sixteenth century, especially in Italy. Almost all examples we have found are portraits or images of Christ on the Cross. Only in the next century does one encounter an occasional parchment proof: for example, by Jan van de Velde I, Salomon Savery, Samuel van Hoogstraten, and Jan van der Heyden. And Rembrandt alone freely exploited the ways in which ink lay on the surface of parchment, mostly during the 1650s, especially in the proofs of *The Three Crosses, St. Francis Beneath a Tree Praying,* and several portraits that maximized the rich and velvety tonal character of the printed image on the skin.[38] Thus any serious collector, from the sixteenth century down to our day, would have realized the rarity and special appeal of a fine print on parchment.

Analysis by various methods has determined that the techniques and materials used in the production of these Marcantonio and Marco Dente prints are appropriate for their period.[39] Despite this analysis, precise dating of any of these substances and processes is not really possible, since all have been in continuous use for centuries. Furthermore, the skins have been significantly altered by the addition of adhesives, coatings, and backings that postdate the printing of the images. The fact that at least two of the skins—those of the Zerner *Mars, Venus, and Cupid* and the Marco Dente—were made for earlier use further complicates the problem. Science can be a useful tool, but it does not always provide conclusive answers. In the present case, art historical analysis provides the best hypotheses. These unique prints on parchment are intriguing images of unusual rarity no matter when or why they were created. Their existence and survival are testimony to the enduring fascination we have with printing on parchment: "Printing on vellum [parchment] is word and flesh, bringing to ultimate physical union that magnetic myth of word made flesh."[40]

The author would like to thank Abigail Quandt, Senior Conservator of Manuscripts and Rare Books at the Walters Art Gallery, Baltimore, for generously sharing her knowledge of parchment and for reading the text.

1. Paper imitations of parchment have been created in a variety of ways. Conventional Western paper fibers (linen, cotton, and woodpulp) are treated to increase their translucency. To make "vegetable parchment," the paper is given a bath of sulfuric acid or zinc chloride, washed in water, dried, and then treated with a plasticizing material such as glycerine or glucose. "Imitation parchment" is made by beating in water and highly hydrating a particular type of paper pulp. Papers can be highly glazed by passing them through heated rollers. Infusion with gums, resins, oils, and petroleum distillates can also render paper more translucent. Japanese "vellum" papers consist of different Asian (gampi and mitsumata) fibers that are made into very smooth sheets and sometimes callendered by pressing. For more information, see Penny Jenkins, "Vexed by Vellum," *The Paper Conservator* 16 (1992): 62–66.

2. Parchment is notoriously reactive to changes in humidity and moisture content. People joke about parchment's desire to return to the "original" shape of the animal. Water can be very damaging to parchment. If the skins get too wet, the reorganized, highly stressed fiber structure relaxes and becomes more transparent.

3. There has been some discussion whether the *Dead Sea Scrolls* are leather or parchment. Current research indicates that they are parchment, as a light tanning on the outer surfaces is not enough to make them a true "leather."

4. A. Lucas, *Ancient Egyptian Materials and Industries* (London, 1948), cited in Michael L. Ryder, "Parchment—Its History, Manufacture and Composition," in *Library Conservation Preservation in Perspective* (Strasbourg, PA: Dowden, Hutchinson and Ross, Inc., 1978), 85.

5. See Ryder, 86.

6. Until the early nineteenth century, Western paper was composed of cellulose fibers derived from clothing rags made of plant materials (linen and cotton). Occasionally, small quantities of silk and wool were mixed in as well. (Cotton fiber was uncommon until the invention of the cotton gin by Eli Whitney in 1793. Woodpulp and Asian bast fibers were not generally common in the West until the nineteenth century.) Parchment, on the other hand, is made of collagen fibers, collagen being the fibrous protein that is the principal constituent of the connective tissue fibrils in animal skin.

7. The earliest use of paper in Europe has been cited as 1102 in Sicily. See Dard Hunter, *Papermaking: The History and Technique of an Ancient Craft* (New York: Alfred Knopf, Inc., 1944), 318.

8. According to R. J. Forbes, skins from hogs, asses, and wolves were used in ancient times, and D. V. Thompson suggests that rabbit skin was used. See Ryder, 87.

9. Ibid., 392.

10. W. Horman, "Vulgaria Uiri doctissimi Guil Hormani," cited in Christopher Clarkson, "Rediscovering Parchment: The Nature of the Beast," *The Paper Conservator* 16 (1992): 5.

11. Early laid papers were generally rougher, being formed with wire laid paper molds whose structure imparted a ribbed gridwork to the surface of the paper.

12. The use of parchment for engraved documents continues today. Sometimes the outer leaves of a book and the manuscript illumination pages were made of parchment, and the rest of the leaves were paper. Metallic pigments and watercolor greens (such as verdigris) would seep into paper and discolor it, but on the smoother and denser parchment, these design materials appeared to "float" on the surface. Early books on paper were often reinforced with parchment along the spine folds. I am grateful for this information provided by Abigail Quandt.

13. Ferris, 26.

14. Ibid., 27–38. Sizing seals the surface, preventing design materials from blurring and seeping into the skin.

15. Clarkson, 5.

16. Benjamin Vorst, "Parchment Making—Ancient and Modern," *Fine Print* 112 (Oct. 1986): 220.

17. Ferris, 32.

18. Goats, plentiful in continental Europe at this period, were a common source of parchment.

19. I am grateful to Richard Newman, Research Scientist, Museum of Fine Arts, Boston, for doing this analysis. Analytical Report, July 12, 1999.

20. Penley Knipe, unpublished paper titled "Grounds on Paper: An Examination of Eight Early Drawings," 1997/98. Advanced Level intern paper at the Straus Center for Conservation, Harvard University Art Museums.

21. I am grateful to Abigail Quandt for pointing out the scraping and for sharing her expertise on parchment with me.

22. I am again grateful to Abigail Quandt for her identification of the scraping.

23. Experimental proof prints on parchment were also done over a century later by Rembrandt van Rijn, ca. 1653. Ten out of the thirteen proof impressions of the first state of his *Three Crosses* are on parchment. Rembrandt also printed on Japanese papers that were so smooth and lustrous that they were referred to as "vellum." Imitation vellum/parchment papers have been made to imitate the unique qualities of parchment without the expense and difficulty. These "parchment papers" are so pervasive that many think parchment is really a paper product.

24. Examination of the verso with long wave ultraviolet light intensified the eradicated ink document, making it slightly more legible. I am grateful to Robert Babcock, Edwin J. Beinecke Curator of Early Books and Manuscripts at the Beinecke Rare Book and Manuscript Library, for reading and dating this inscription.

25. This coating was analyzed by gas chromatography/mass spectrometry, which suggested the presence of nondrying or semidrying oil. In addition, straight-chain hydrocarbons (characteristic of paraffin-type waxes) were detected at very low levels, as were two common oxidation products of conifer resins. The trace of conifer resin may be a contaminant, but possibly an oil-resin mixture was applied to the surface. Under ultraviolet light, the oil and resin surface coating fluoresced in the manner of natural aged oil films. I am grateful to Richard Newman for the analysis. Analytical Report, July 12, 1999.

26. There is also a history of using oil to transparentize parchment (and paper) so that they could be used for tracing or transferring designs. There is no evidence, however, that such a practice is applicable to this print.

27. I am grateful to Richard Newman for this analysis. Analytical Report, July 12, 1999.

28. DNA analysis has been done with the *Dead Sea Scrolls*. In our prints, the test would require carefully removing the root of hairs for testing. This can be done safely under the microscope without damaging the skins. We hope to pursue this in the future.

29. The area of the shield masked in the Zerner impression may have been the same size as well, but the non-printed area appears to be slightly larger than in the other two impressions. This difference may be due to the dimensional changes the thicker skin underwent during moistening and printing.

30. The dark areas on the versos of the skins may be a result of discolored residual adhesive, probably animal glue. Analysis was unsuccessful in isolating and identifying the adhesive, as it is similar to or the same as the protein of the parchment support.

31. All of the printing inks in these impressions would have been carbon-based pigments with a boiled drying oil such as linseed oil. For information on early Italian printing inks, see Annette Manick's essay in Sue Reed and Richard Wallace, *Italian Etchers of the Renaissance and Baroque* (Boston: Museum of Fine Arts, 1989), xliv-xlvii.

32. Solidly backing parchment is not a treatment currently subscribed to both because it flattens the parchment in an unnatural manner, and because the adhesives and pressure used in mounting transparentize the white pigment preparations as well as the parchment itself. There are a number of theories about how to best mount parchment to help it stay in plane. Many believe one needs to restrain it gently around the perimeter with numerous small attachments that will release if the skin is under too much tension, thereby avoiding any possibility of tearing. The original technique has been referred to as string mounting. The parchment looks like a little trampoline that is supported by numerous strings in a mat/mount. This slight restraint conceptually imitates the original tensioning frames used to make parchment, but is much gentler, solely supporting the skin. For more information, see Christopher Clarkson, "Preservation and Display of Single Parchment Leaves and Fragments," in *The Conservation of Archives, Works of Art on Paper and Library Materials,* ed. Petherbridge (London: Butterworths, 1997), 201-209; and Nicholas Pickwood, "Alternative Methods of Mounting Parchment for Framing and Exhibition," *The Paper Conservator* 16 (1992): 78-85. It is most

important to control the environment in which parchment is kept: radical fluctuations in relative humidity and temperature are the most damaging. Maintaining a narrow range somewhere within 45–55% RH and 65–72° is reasonable. It is important to choose a temperature and humidity that are realistically maintainable.

33. I am grateful to Dr. Robert Babcock for examining the text.

34. I am grateful to Suzanne Boorsch, Associate Curator of Drawings and Prints, Metropolitan Museum of Art, New York, for this information.

35. David Landau and Peter Parshall, *The Renaissance Print, 1470–1550* (New Haven: Yale University Press, 1994), 302.

36. The three impressions where the "1508" or "1508 16D" or "16D" have been scraped away include two at the Metropolitan Museum of Art (cats. 8, 9); and one at the Davison Art Center, Wesleyan University (cat. 10).

37. Watermarks are images created in the paper by stitching thicker bent wires in a design onto the paper mold. When the wet pulp drains through the mold, less paper pulp is deposited on top of the thicker watermark wires, therefore transmitting more light through the paper and creating the watermark. Watermarks are sometimes useful for rough dating and identifying where a given piece of paper was made. A watermark of a "tree in a circle" has been identified on impressions of *Mars, Venus, and Cupid* owned by Yale University and the Metropolitan Museum of Art (cats. 2, 8). The closest match of a published watermark with a "tree within a circle" (with a six-pointed star above) is found in David Woodward, *Catalogue of Watermarks on Italian Printed Maps* (Chicago: University of Chicago Press, 1966), no. 126. Another close match is found on paper from a document of 1546; see Aurelio and Augusto Zonghi, *Zonghi's Watermarks,* vol. 3 of *Monumenta Chartae Papyracae Historiam Illustrantia,* ed. E. J. Labarre (Hilversum, Holland: The Paper Publications Society, 1953), no. 1733. A very similar watermark with a tree in a circle (with more leaves than in our watermark and a star at the top) is found in C.-M. Briquet, *Les filigranes. Dictionnaire historique des marques du papier* 1, ed. Allan Stevenson (Amsterdam: The Paper Publications Society, 1968), no. 773. Briquet found this mark on documents in Livorno and Rome dating from 1512 to 1516. It is possible that the paper is from Fabriano. Briquet suggests the tree probably refers to the Della Rovere family. If so,

the terminus a quo for its use on a Fabriano paper would be 1508, when Francesco Maria Della Rovere became Duke of Urbino. Foligno may have been another possible source for this paper. I am grateful to Conor Fahy, Andrea Lothe from Die Deutsche Bibliothek, and to Professor Daniel Mosser from Virginia Technical College for sharing this watermark and paper information with me. The dates of these documented papers with watermarks are appropriate for our Raimondi prints. Paper molds could be used for up to thirty years before they wore out.

Chain lines are the visual characteristic created by the less dense paper pulp disposition caused by wires stitching the laid wires onto the wooden ribs of the papermaking mold. The Yale University Art Gallery and Metropolitan Museum of Art impressions have a chain line that goes vertically through the center of the watermark. Chain lines vertically bisecting watermarks are a feature of Italian papers noted by Elizabeth Lunning in her essay, "Characteristics of Italian Paper in the Seventeenth Century," in Reed and Wallace, *Italian Etchers of the Renaissance and Baroque,* xxxii–xliii. I am grateful to Suzanne Boorsch and the staff of the Paper Conservation Laboratory at the Metropolitan Museum of Art for showing me their Marcantonios and the Marco Dente of the *Virgin and Child with Tobias and the Angel and St. Jerome.*

38. For information on Rembrandt prints on parchment, see note 23 above.

39. The methods of examination and analysis that were employed included: stereomicroscopic and ultraviolet examination, x-ray fluorescence, infrared reflectography, Fourier Transform Infrared Reflectography, and gas chromatography. Future DNA anlaysis may be undertaken to determine whether any of the skins are from the same goat. For those interested in exploring what sorts of analyses are possible, extensive testing and dating have been done on the parchment of Beinecke Library's Vinland Map, which records the Vikings' 1440 discovery of North America. Recent testing indicates that the parchment is old, but that it has been treated with more modern materials that complicate the analysis.

40. Decherd Turner, "Introduction," in *The Mystique of Vellum,* ed. Decherd Turner, Colin Franklin, and Richard Bigus (Boston: Brommer Booksellers, Inc., 1984), 13. This book's title inspired the use of the word "mystique" in the title of the present essay.

Marcantonio Printing / Printing Marcantonio

LISA PON

MARCANTONIO RAIMONDI, the most outstanding engraver of the Italian High Renaissance, has long enjoyed a multifaceted reputation.[1] For Giorgio Vasari in the sixteenth century, he was the printmaker whose biography provided the context for a history of printmaking within a project devoted almost exclusively to the lives of painters, sculptors, and architects.[2] For many, including Nicholas Poussin in the seventeenth century and Edouard Manet in the nineteenth, Marcantonio was the engraver whose prints allowed them to study Raphael's designs.[3] For Adam Bartsch in the nineteenth century, he was the perfect translator of Raphael's compositions from drawing into print.[4] And for William Ivins in the century now ending, Marcantonio was the inventor of a syntax of flicks and strokes of the burin that allowed a systematic depiction of three-dimensional surfaces.[5]

The current exhibition, *Changing Impressions: Marcantonio Raimondi and Sixteenth-Century Print Connoisseurship,* highlights another aspect of Marcantonio's output which until now has not been fully investigated: the fact that at least one of the copper plates he engraved was used to produce impressions of puzzling complexity and uncertain intent. While the prints featured in this exhibition — the nine impressions on paper and parchment of Marcantonio's *Mars, Venus, and Cupid* — pose unique problems, a number of other works have been included to provide a broader context. This brief introduction will therefore survey some of the histories and variables of Marcantonio's plates, focusing on how both he and the publishers who owned the plates after his death printed, altered, and copied them.

❧

Engraving, as an intaglio form of printmaking, involves laboriously cutting grooves into a copper plate with a pointed tool called a burin, and then rubbing ink into those grooves. Dampened paper — or less often, parchment — is laid over the inked plate. The paper and plate are then sandwiched under a stack of cushioning felts and subjected to the high pressure of a roller press. The pressure of the double rollers, much higher than that provided by the screw press used for relief printing (woodcuts and type), molds the paper into the grooves so that the ink is squeezed onto the paper, yielding an impression. The plate can then be further engraved if desired, adding new lines to those that already existed. Conversely, it is possible to remove passages by burnishing,

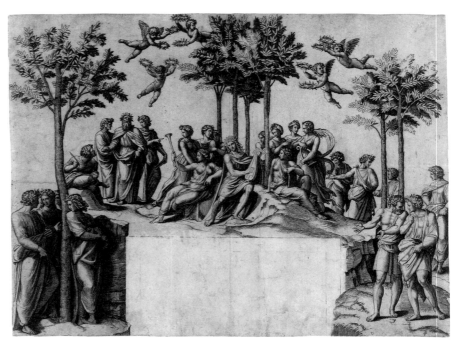

fig. 18

Marcantonio Raimondi with Raphael, Apollo on Parnassus, *1517–20. Engraving, 357 x 471; B.XIV.200.247; D.110, unique first state. The Cleveland Museum of Art. Gift of the Print Club of Cleveland. 1963.231.* This is the only known impression of the plate before Marcantonio (or an assistant) finished the figures at the lower right and the leaves in the trees. Very likely, it also lacked the doors in the center; at some time this area of the print was thinned and, it is conjectured, the "missing" doors supplied by a detail cut from another impression. [cat. 26]

rendering them smooth and no longer able to hold and print ink. When this reworked plate is printed, the resulting impression is termed a new state.[6]

Sometimes the engraver printed the plate before fully realizing the image, in order to judge the progress made. Such trial states or proofs are rare, often existing as a single impression meant only for the engraver's eyes. This is the case with the virtually unknown proof of Giulio Bonasone's *Calypso* (fig. 6) and with the proof of one of Marcantonio's most celebrated prints, his engraving after Raphael's *Parnassus* (fig. 18).[7] Comparison with a complete state impression (fig. 19) shows that Marcantonio had worked up the figures at the center and lower left before completing the figures at the lower right and the leaves in the trees, or turning to the window at the bottom of the composition.[8] The proof may have been pulled at a crucial point in the process of engraving, when Marcantonio gave the plate to an assistant to complete the unfinished areas.[9]

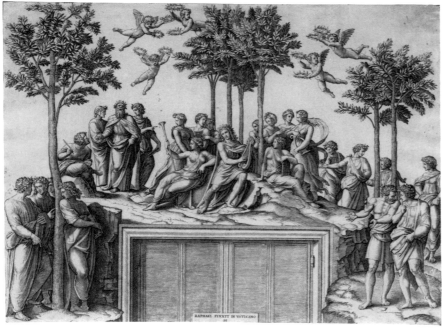

fig. 19

Marcantonio Raimondi with Raphael, Apollo on Parnassus, *1517–20. Engraving, 356 x 470; B.XIV.200.247; D.110, second state. Yale University Art Gallery. University Purchase. 1954.9.9.* This is a reasonably good impression of the finished plate. [cat. 27]

At some later date in the proof's history, the blank area for the window was scraped to remove the top surface of the paper and, possibly, additional printing that had appeared there. This scraping was perhaps done before 1917, when the impression was still mounted on canvas and described as a "trial proof, before the Doors were engraved, before the Trees were finished, and before considerable work on the Figures."[10] It was certainly done before 1962, when Craddock and Barnard noted that "the paper is slightly skinned at the front surface in the blank rectangle at foot" and suggested that this scraping or skinning was done to accommodate "doors cut from a later completed state...formerly...pasted over this area and subsequently removed."[11] Certainly there are examples of cutting up a print and pasting the pieces over the corresponding areas of another impression to improve the image as a whole. In the mid-nineteenth century, for example, the Boston collector Francis Calley Gray had a poor impression of Marcantonio's *Massacre of the Innocents* (with fir

tree), which incorporated no fewer than six irregularly shaped printed patches to cover unacceptably damaged areas.[12] But in the case of *Parnassus,* however, it is tempting to speculate that the scraped area originally contained Marcantonio's MAF monogram, as it appears at the bottom edge in the complete state. The presence of that monogram would make this proof impression identical to a first state described in Henri Delaborde's 1888 monograph on Marcantonio,[13] and of which I have found no subsequent trace or mention.

Different *states* of an engraving, then, are produced by printing from the same plate, which has been reworked in some way. Different *versions* of an engraving are made by cutting entirely new plates with the same composition. Marcantonio engraved successive versions of at least a dozen compositions[14] and may have engraved two different versions of his most popular print, the aforementioned *Massacre of the Innocents* (figs. 20, 21).[15] In addition, *copies* of both of these versions were made with varying degrees of competence by others in the sixteenth century and later.[16]

One of Marcantonio's major concerns as a printmaker was how to produce intermediate gray tones in a medium offering only the darkness of printing ink and the lightness of the paper or parchment support. His earliest experiments with linear strokes and stipples soon gave way to the more systematic crosshatchings lauded by Ivins. In the course of developing his mature style of engraving, Marcantonio turned three times to the difficult problem of printing middle tones in the depiction of night scenes. First, around 1507–8 in the so-called *Dream of Raphael,* Marcantonio placed two reclining female nudes in a mysterious landscape of waterside buildings dimly lit by artificial light, fading daylight, and fire.[17] In this relatively early effort, variations in the light are represented by differing types of burin strokes. The brightest portions of the scene are left completely untouched by the burin. The dimly illuminated forms of the reclining figures are shaped by long, curving strokes; the darkest areas of the landscape by dense, straight hatchings that cross each other at right angles in the reflections in the water; and the transitions between light and dark by a concentration of flicks and stipples.

Marcantonio's next nocturnal scene, *Il Morbetto (The Plague)* of ca. 1515–16 (fig. 22), depicts the plague of Phrygia as described in Virgil's *Aeneid.*[18] In the darkest corner at upper left, Aeneas in his bedchamber receives divine word to leave Crete: "the sacred images of the gods, the Phrygian Penates, whom I had borne with me from Troy out of the midst of the

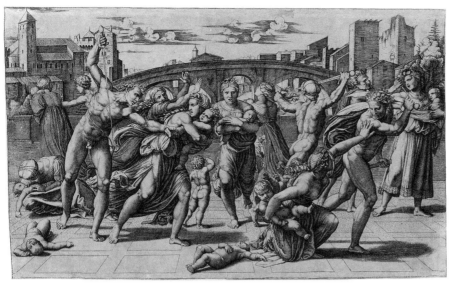

fig. 20

Marcantonio Raimondi with Raphael, Massacre of the Innocents, *1511–12. Engraving, 276 x 429; B.XIV.21.18; D.8, the so-called first version with the fir tree (at the upper right). The Metropolitan Museum of Art. Gift of Felix M. Warburg and his Family, 1941*

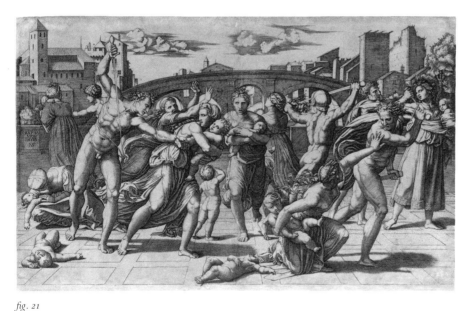

fig. 21

Marcantonio Raimondi with Raphael, Massacre of the Innocents, *1513–15. Engraving, 276 x 429; B.XIV.21.20; D.8, the so-called second version without the fir tree (at the upper right). Yale University Art Gallery. Everett V. Meeks, B.A. 1901, Fund. 1956.9.48. Most scholars accept both versions of this print as being by Marcantonio. This second plate may have been engraved by the artist to compete with Raphael's publisher, il Baviera, who seems to have had exclusive rights to the first plate. [cat. 21]*

fig. 22

Marcantonio Raimondi with Raphael, Il Morbetto (The Plague), *1515–16. Engraving, 195 x 248;* B.XIV.314.417; D.189, *second state of three. Davison Art Center, Wesleyan University. 1960.14.11.* This impression represents the extraordinary beauty that could be extracted by the artist from his plates before they began to show the inevitable signs of wear. [cat. 22]

burning city, seemed as I lay in slumber to stand before my eyes, clear in the flood of light, where the full moon streamed through the inset windows."[19] Marcantonio shows the two divine figures bathed in luminous rays shaped by parallel strokes of the burin, while Aeneas in his slumber fades into the darkness of dense crosshatchings. At lower left, a man illuminates the bodies of dead and dying livestock with a torch whose flickering flame is shaped not by a finite outline but by the irregular ends of the surrounding crosshatching. This nocturnal foreground scene and the brighter right side of the print illustrate the continuous day-and-night action described by the imperfect tense of the inscription on the pedestal of the herm at center: "Men gave up their sweet lives, or dragged enfeebled frames."[20] The measured burin strokes of the daylight half of the print are typical of Marcantonio's mature style.

Marcantonio's next attempt at a scene combining day and night, *Judgment of Paris* of around 1517–20, is one of the triumphs of that mature style of engraving and also one of his most technically innovative prints (cats. 24, 25).[21] Before engraving the copper plate with the burin, Marcantonio indiscriminately scratched its entire surface with a light abrasive, perhaps a pumice stone. These shallow scratches would catch some ink, but less than a burin-engraved furrow would, resulting in a generalized grayish tone when printed. As with *Il Morbetto,* part of the action takes place at night, while the rest occurs in daylight. Paris with the three goddesses being judged at center, as well as the nymphs and river gods at left and right, are shown in the gray gloom of night. Above them, the sun god Apollo in his chariot brings the day and drives away his sister Diana, goddess of the moon, who retreats at the upper right. In order to achieve the completely blank brightness of the paper representing the sunlit portions of the print, Marcantonio had to remove the pumice scratches by laboriously rubbing the plate with a burnisher, a tool that smooths the metal surface. Thus in this print, Marcantonio first worked the plate so it would print a middle tone, then turned to the burin for the dark tones and the burnisher for the light ones. The process of working with a burnisher to produce light tones from darker ones anticipates the technique of mezzotint engraving, which would not come into wide use until the late 1600s, more than a century later.

After Marcantonio's death, many of the plates he had engraved were owned and printed by others.[22] In the sixteenth century, a substantial number, including his plate for the *Judgment of Paris,* became the property of the

publisher Antonio Salamanca, who was active in Rome beginning around 1519.[23] Some of them were passed on to Salamanca's younger partner, Antonio Lafrery, then eventually to the seventeenth-century Roman publishing family of Giuseppe, Giovanni-Giacomo, and Domenico de'Rossi.[24] In 1738, the de'Rossi heir, Lorenzo Filippo, sold the family's entire stock of engraved plates to Pope Clement XII, who formed the Calcografia Camerale Romana to house it.[25] The Calcografia Camerale became the Calcografia Regia in 1870 and is now the Calcografia Nazionale in Rome.

As late as 1934, the Calcografia continued to print and sell impressions from Marcantonio's plates. In these late impressions, many of the finer details and the crispness of lines engraved by burin have been lost, worn away by repeatedly submitting the copper plate to the heavy pressure of the printing press. Furthermore, some of the plates had been reworked with a burin by their former owners in an attempt to restore worn or lost details, a process that resulted in coarsened impressions. One of the plates in the Calcografia's collection, the *Dance of Putti,* was already described in 1813 as "retouched in all its parts in such a manner that one no longer finds the least trace of the work of Marcantoni."[26] The plate also bore the inscription ANT.SAL.EXC, indicating that three centuries earlier it had been one of the plates owned and published ("excudit") by Antonio Salamanca.[27]

Sometime between 1881 and 1927, the Calcografia acquired the seventeen plates for Marcantonio's engravings of 1506 copying Albrecht Dürer's woodcut series, *The Life of the Virgin* (fig. 23).[28] The second states of Marcantonio's copies bear numbers engraved at the lower margin, indicating their place in the series. For example, a small number "17" can be seen at the bottom of the exhibited impression of the last plate in the series, *The Glorification of the Virgin* (fig. 24).[29] Sometime prior to the Calcografia's acquisition, however, an owner of this plate had tried to remove the number by burnishing (fig. 25), perhaps to produce impressions that might pass for the more valued first state, which lacks the number. But whereas the shallow abrasions left by the pumice could be burnished smooth in the *Judgment of Paris,* the deeper engraved strokes of the "17" resisted removal.[30] Late impressions showing traces of this partially removed number abound, since as recently as 1934 they were printed by the Calcografia and sold for 20 lire, or included as part of the set of seventeen prints for 250 lire.[31]

Of course, not all Marcantonio plates were printed so far into our own century. Some were destroyed by accident or design, or were treated so

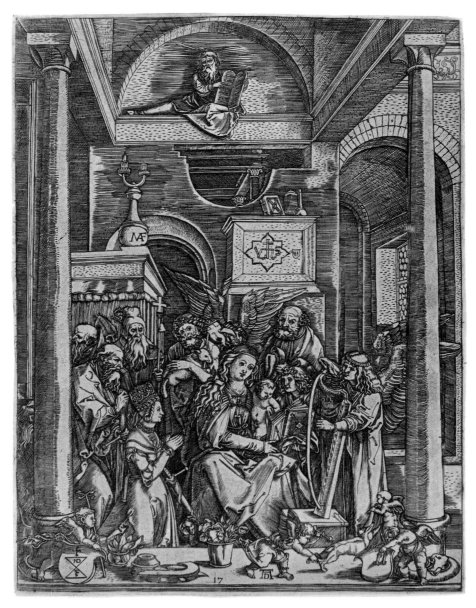

fig. 24

Marcantonio Raimondi after Albrecht Dürer, The Glorification of the Virgin, *1504–08. Engraving, 295 x 216;*
B.XIV.407.637; D.251. Harvard Art Museums. Gift of Belinda L. Randall from the collection of John Witt Randall.
R 781 [cat. 17]

fig. 25

Detail of the copper plate for Marcantonio Raimondi after Albrecht Dürer, The Glorifica-
tion of the Virgin, *1504–08. Engraved copper plate, 295 x 216; B.XIV.407.637; D.251.
Photograph courtesy of the Istituto Nazionale per la Grafica, Rome. The copper plates of
Marcantonio's* Life of the Virgin *were eventually supplied with numbers. This illus-
tration reveals the present condition of the surviving plate, from which the number
"17" has been rather crudely burnished.*

that they could not be printed. Sometime before 1813, the plate for *Young
Man Protected by Fortune* (cat. 19) was scored with nine diagonal strokes form-
ing multiple x's across the composition.[32] Obviously, such mutilation of the
plate was undertaken so that no more prints could be pulled from it. Cancel-
ing a plate in this fashion was not uncommon in the later nineteenth century,
when a taste for limited editions of rather few impressions arose, but it was
precocious in 1813.[33] In fact, it is patently manifest that Marcantonio's plates
were used over and over again to satisfy an unending thirst — on the part
of artists and collectors alike — for images of renowned Italian Renaissance
motifs. An example of an impression from the completely worn-out plate
for *Il Morbetto* is included in the exhibition (cat. 23). Although the paleness
or growing crudeness of prints pulled from worn, reworked, or copied plates
has been reviled by print connoisseurs, their very quantity reveals the over-
whelming importance and popularity of Marcantonio's prints and the compo-
sitions they conveyed.

I would like to thank Clay Dean and Richard S. Field for their invitation to contribute this essay, and Marjorie Cohn and Stephan Wolohojian for their thoughtful comments on earlier drafts. I also appreciate having had the opportunity to examine some of the prints in the exhibition in the company of Theresa Fairbanks, Christopher Wood, Mr. Dean, and Dr. Field.

1. For a survey of the Marcantonio literature through the centuries, see Marzia Faietti, "Lineamenti della fortuna critica di Marcantonio," in Marzia Faietti and Konrad Oberhuber, *Bologna e l'Umanesimo, 1490–1510* (Bologna: Nuova Alfa Editoriale, 1988), 45–50.

2. On Vasari's use of prints and attitudes towards printmaking, see David Landau, "Vasari, Prints and Prejudice," *Oxford Art Journal* 6 (1983): 3–10; Evelina Borea, "Vasari e le stampe," *Prospettiva* 57–60 (1989–90): 18–38; and Sharon Gregory, "Dürer's Treatise on Fortifications in Vasari's Workshop," *Print Quarterly* 12 (1995): 275–79.

3. See Elizabeth Broun, "The Portable Raphael," in Innis Shoemaker and Elizabeth Broun, *The Engravings of Marcantonio Raimondi* (Lawrence, KS: The Spencer Museum of Art, 1981), 31–33, 36–37. On the reception of Manet's use of Raphael's composition in *Déjeuner sur l'herbe,* see Hubert Damisch, *The Judgment of Paris,* trans. J. Goodman (Chicago: University of Chicago Press, 1996), 73–75; and Michael Fried, *Manet's Modernism, or the Face of Painting in the 1860s* (Chicago: University of Chicago Press, 1996), 131, 137–38.

4. Adam Bartsch, *Le Peintre graveur* 1 (Vienna: Degen, 1803), 3. But for a different view of Raphael's relationship with Marcantonio, see my "Note on Marcantonio and Raphael," forthcoming in *Print Quarterly.*

5. William B. Ivins, Jr., *Prints and Visual Communication* (Cambridge, MA: MIT Press, 1953), 65.

6. For more on the technique of engraving, see Carlo James et al., *Old Master Prints and Drawings: A Guide to Preservation and Conservation,* trans. M. Cohn (Amsterdam: Amsterdam University Press, 1997), 94–99, 109–10; and Bamber Gascoigne, *How to Identify Prints: a complete guide to manual mechanical processes from woodcut to ink jet* (New York: Thames and Hudson, 1986), section 9A.

7. Bartsch, *Le Peintre graveur* 14 (1813), no. 247. Bartsch numbers for Marcantonio's prints will hereafter be cited as B.

8. Other Renaissance engravers worked differently. For example, Giorgio Ghisi worked systematically from left to upper right on the plate for *The Dream of Raphael,* and from the figures below to the landscape above in his *Nativity* after Bronzino; see Michael Bury, "On Some Engravings by Giorgio Ghisi Commonly Called 'Reproductive,'" *Print Quarterly* 10 (1993): 4–19. In his 1504 *Adam and Eve,* Albrecht Dürer worked from right to left on the plate, filling in most of the details of the forest backdrop across three-quarters of the plate before turning to Adam's right and then left leg, while leaving Eve and the landscape behind her in outline; see Walter Strauss, ed., *The Illustrated Bartsch* 10 (Commentary): *Albrecht Dürer* (New York: Abaris Books, 1981), 10–13.

9. The suggestion that the *Parnassus* was engraved by more than one hand was first made by Bernice Davidson on purely stylistic grounds before the Cleveland proof came to light in 1963 ("Marcantonio Raimondi, The Engravings of his Roman Period" [Ph.D. diss., Radcliffe College, Harvard University, 1954], 95–96). It is surely one of the minor triumphs of mid-twentieth-century connoisseurship that her suggestion was supported by the reappearance of the proof.

10. Sotheby, Wilkinson, and Hodge, *Catalogue of Prints, Drawings, Pictures, and Armor from the Collection of the Earl of Pembroke and Montgomery* (London, July 1917), 14, no. 188.

11. Craddock and Barnard, *Engravings and Etchings, Fifteenth–Nineteenth Centuries: Recent Acquisitions* (London, 12 May 1962), 20, no. 85, pl. VIII.

12. B.20. This impression is now in the collection of the Fogg Art Museum, G2483. The patches, still in place, are cut from an impression of the *Massacre of the Innocents without Fir Tree* (B.18).

13. Henri Delaborde, *Marc-Antoine Raimondi: Etude historique et critique suivie d'un catalogue raisonné des oeuvres du maître* (Paris: Librarie de l'Art, 1888), 156.

14. See David Landau and Peter Parshall, *The Renaissance Print, 1470–1550* (New Haven: Yale University Press, 1994), 131–33, 389 n.117.

15. B.18 and 20. I believe that Marcantonio engraved both versions, the so-called *Massacre with Fir Tree* around 1511–12 and the *Massacre without Fir Tree* in 1513–15, but the matter is open to debate. For a summary of various published opinions, see Shoemaker and Broun, 108.

16. See Grazia Bernini Pezzini et al., *Raphael Invenit: stampe da Raffaello nelle collezioni dell'Istituto nazionale per la grafica* (Rome: Edizioni Quasar, 1985), 172–73, 672–74.

17. B.359. This common title, *The Dream of Raphael,* was first used in the eighteenth century by Karl-Heinrich Heinecken, *Dictionnaire des artists, dont nous avons des estampes, avec une notice detaillée de leur ouvrages gravés* 1 (Leipzig: J.G.I. Breitkopf, 1778), 323 n.34. See also Faietti and Oberhuber, 157, 158 n.1.

18. B.417.

19. Aeneid 3.148–52. I have used the translation by H. R. Fairclough (*Virgil, Eclogues, Georgics, Aeneid I–VI* [Cambridge, MA: Harvard University Press, 1956], 359).

20. Aeneid 3.140.

21. B.245.

22. A lack of documentation makes it impossible to pinpoint the years of Marcantonio's birth or death, but it is generally believed that he lived from around 1475–80 until some time before 1534; see Shoemaker and Broun, xiv-xv. Impressions printed after an artist's death are not often discussed in the scholarly literature. For an exception, see Marjorie Cohn, "Retroussage in Cranach's *Penance of St. John Chrysostom,*" in *Shop Talk: Studies in Honor of Seymour Slive, Presented on his Seventy-fifth Birthday* (Cambridge, MA: Harvard University Art Museums, 1995), 55–58, 298–99.

23. Landau and Parshall, 302–4. See also Maria Cristina Misiti, "Antonio Salamanca: Qualche chiarimento biografico alla luce di un'indagine sulla presenza spagnola a Roma nel Cinquecento," in Michele Santoro, *La Stampa in Italia nel Cinquecento* (Rome: Bulzoni editore, 1992), 545–63. I thank Pat Simons for this reference.

24. Landau and Parshall, 132. See also *Catalogo generale delle stampe tratte dai rami incisi posseduti dalla Regia Calcografia di Roma* (Rome: Regia Calcografia di Roma, 1934), 3.

25. Lorenzo Filippo had begun negotiations to sell the plates to the English in 1732; the Pope wanted to keep the plates in Italy. See Carlo Alberto Petrucci, *Catalogo generale delle stampe tratte dai rami incisi posseduti dalla Calcografia Nazionale* (Rome: La Libreria dello Stato, 1953), 3.

26. Bartsch, *Le Peintre graveur* 14 (1813), 278, no. 217.

27. There are instances when one can follow a plate's progress through a genealogical series of publisher's inscriptions. For example, Giorgio Ghisi's engraving of Michelangelo's *Last Judgment* has the names of no less than four publishers added to or burnished out from successive states. See Alida Moltedo, *La Sistina Riprodotta: Gli Affreschi di Michelangelo dalle Stampe del Cinquecento alle Campagne Fotografiche Anderson* (Rome: Fratelli Palombi editori, 1991), 69.

28. They were not included in the *Catalogo generale dei rami incisi al bulino ed all'acquaforte posseduti dall Regia Calcografia di Roma le cui stampe si vendono in questo istituo,* published in 1881. In 1927, they were described as "un acquisto relativemente recente" in Benvenuto Disertori's *I rami raimondeschi alla R. Calcografia (Notizia aggiunta al Bartsch)* (Florence: Olschki, 1927), 12–14. For more about these prints and the practice of copying in general, see my essay "Prints and Privileges: Regulating the Image in Sixteenth-Century Italy," *Harvard University Art Museums Bulletin* 6 (1998): 40–64.

29. B.637.

30. Plate 1684/17. I thank Calandra Giusy for her assistance in making the plate available to me for study and in obtaining the photograph published here.

31. For example, the duplicates in the collection of the Harvard University Art Museums (G4820 and R781) both show signs of a partially burnished "17." For prices, see Petrucci, *Catalogo generale,* 187.

32. B.377. Bartsch described the canceled state in *Le Peintre graveur* 14 (1813), 287. An impression now in London from the canceled plate is illustrated in Konrad Oberhuber, ed., *The Illustrated Bartsch: The Works of Marcantonio Raimondi and of his School* (New York: Abaris Books, 1978), 66.

33. The seventeenth century may have gilded plates in order to cancel them. Marco Boschini's literary dialogue on the visual arts, published in Venice in 1660, describes the plate of Agostino Carracci's print after Tintoretto's *Great Crucifixion* as being gilded by Daniel Nys, an art collector from north of the Alps who owned it (*La carta del navegar pitoresco,* 124). And Emperor Rudolf II (d. 1612) had the plate for Dürer's *St. Eustache* of

1509 — or a copy of it — gilded, presumably because he wanted it "to command the same respect as gold" (Joseph Heller, *Das Leben und die Werke Albrecht Dürer* 2 [Leipzig, 1831], 443). The gilding by Rudolf was first mentioned by Bartsch, *Le Peintre graveur* 7 (1808), 73, no. 57. Moriz Thausing, examining a gilt plate of a Düreresque *St. Eustache* in the collection of F. X. Redtenbacher in Austria in 1876, argued it was a copy by the Monogrammist GH (*Dürer: Geschichte seines lebens und seiner Kunst* [Leipzig, 1876], 229 n.1). See also Christiane Andersson and Charles Talbot, *From a Mighty Fortress: Prints, Drawings, and Books in the Age of Luther, 1483–1546* (Detroit: Detroit Institute of Arts, 1983), 249.

An earlier example of a precious-metal printing plate owned by Rudolf II is the silver plate, now in the Kunsthistorisches Museum in Vienna, engraved by Goltzius in 1595: *Bacchus, Ceres, and Venus* (B.155; see Otto Hirschmann, Hendrick Goltzius [Leipzig, 1919], 84–85, 168 n.13; and Walter Melion, "Love and Artisanship in Hendrick Goltzius's *Venus, Bacchus, and Ceres* of 1606," Art History 16 [1993]: 80, 92–93 n. 79, and passim). A limited number of impressions were pulled from this plate, which surely was itself valued, perhaps in the same manner that the silver plaquettes of Rudolf's court goldsmith, Paulus van Vianen, were (see Ger Luijten et al., ed., *Dawn of the Golden Age: Northern Netherlandish Art 1580–1620* [Amsterdam, 1994], 504–6, 508–9). I thank Michael Zell for bringing my attention to Goltzius's plate and for these references.

Checklist of the Exhibition

NOTE *Unless otherwise indicated, measurements are in millimeters and are of the entire sheet. The vast majority of Italian old master prints were trimmed close to or within a couple of millimeters of the platemark. Many of these sheets are also irregular, that is, not perfectly square. The first section focuses on the parchment impressions of Marcantonio's* Mars, Venus, and Cupid *and related sheets, while the second introduces other works by and around Marcantonio, for the most part in chronological order.*

1

Marcantonio Raimondi
(Italian, ca. 1480–ca. 1534)
Mars, Venus, and Cupid, 16 December 1508
Engraving, first state on paper, 300 x 213
Watermark: Anchor in a circle
Bartsch XIV.257.345; Delaborde 119
The British Museum, London [fig. 7]

2

Marcantonio Raimondi
(Italian, ca. 1480–ca. 1534)
Mars, Venus, and Cupid, 16 December 1508
Engraving, second state on paper, 301 x 212
Watermark: Tree within a circle
B.XIV.257.345
Yale University Art Gallery. Gift of the Associates in Fine Arts. 1941.183 [fig. 8]

3

Albrecht Dürer (German, 1471–1528)
The Combat of Virtue and Pleasure in the Presence of Hercules, 1498–99
Engraving, 324 x 225 (plate)
Watermark: High Crown
Bartsch 73; Meder 63
Yale University Art Gallery. The Fritz Achelis Memorial Collection. Gift of Frederick George Achelis, B.A. 1907. 1925.14 [fig. 9]

4

Marcantonio Raimondi
(Italian, ca. 1480–ca. 1534)
Mars, Venus, and Cupid, date and monogram partially effaced
Engraving, altered second state on parchment, 291 x 199
B.XIV.257.345
Yale University Art Gallery. Bequest of Lydia Evans Tunnard. 1981.60.27 [fig. 1; front and back cover]

5

Marcantonio Raimondi
(Italian, ca. 1480–ca. 1534)
Mars, Venus, and Cupid, 16 December 1508
Engraving, altered second state on parchment, 286 x 193
B.XIV.257.345
Lent by Hill-Stone, Inc., New York [fig. 2]

6

Marcantonio Raimondi
(Italian, ca. 1480–ca. 1534)
Mars, Venus, and Cupid, 16 December 1508
Engraving, altered second state on parchment, 281 x 200
B.XIV.257.345
The Spencer Museum of Art, University of Kansas. Gift of the Max Kade Foundation [fig. 3]

7

Marcantonio Raimondi
(Italian, ca. 1480–ca. 1534)
Mars, Venus, and Cupid, date and monogram effaced
Engraving, altered second state on parchment; manuscript on verso, 290 x 202
B.XIV.257.345
Collections: Paul Davidsohn; Dr. F. Lieberg
Lent by Henri Zerner, Cambridge, MA [fig. 4]

8

Marcantonio Raimondi
(Italian, ca. 1480–ca. 1534)
Mars, Venus, and Cupid, date partially effaced
Engraving, second state on paper, 296 x 207
Watermark: Tree within a circle
B.XIV.257.345
The Metropolitan Museum of Art. Gift of Henry Walters, 1917. 17.37.302 [fig. 10: detail]

9

Marcantonio Raimondi
(Italian, ca. 1480–ca. 1534)
Mars, Venus, and Cupid, date effaced
Engraving, second state on paper, 289 x 208
Watermark: Three mounts with a fleur-de-lys
and an "M"
B.XIV.257.345
The Metropolitan Museum of Art. Rogers Fund,
1918. 18.84.2 [fig. 11: detail]

10

Marcantonio Raimondi
(Italian, ca. 1480–ca. 1534)
Mars, Venus, and Cupid
Engraving, second state on thin, coarsely
structured paper, 301 x 212
B.XIV.257.345
Davison Art Center, Wesleyan University,
47.D1.204

11

Marco Dente da Ravenna
(Italian, ca. 1480–1527)
*Virgin and Child with Tobias and the Angel
and St. Jerome*
Engraving, 263 x 219
Watermark: Anchor in a circle
B.XIV.61.54, first state
The Metropolitan Museum of Art. Gift of
Henry Walters, by exchange, 1931. 1931.31.24
[fig. 12]

12

Marco Dente da Ravenna
(Italian, ca. 1480–1527)
*Virgin and Child with Tobias and the Angel
and St. Jerome,* ca. 1540–50
Engraving, 257 x 217
B.XIV.61.54, second state with address of
A. Salamanca and false Marcantonio monogram
The Metropolitan Museum of Art. Gift of
Michel Benisovitch, 1930. 1930.42.4 [fig. 13]

13

Marco Dente da Ravenna
(Italian, ca. 1480–1527)
*Virgin and Child with Tobias and the Angel
and St. Jerome*
Engraving, altered late impression on parchment
with false monogram of Marcantonio removed by
masking; manuscript on recto and verso, 258 x 220
B.XIV.61.54
Lent by Randal H. Keynes, London

14

School of Marcantonio Raimondi
after Marco Dente da Ravenna
(Italian, ca. 1480–1527)
*Virgin and Child with Tobias and the Angel
and St. Jerome*
Engraving, 289 x 212
Watermark: Anchor in a circle
B.XIV.61.54A
Yale University Art Gallery. Library Transfer.
1967.4.30

15

Giulio Bonasone (Italian, ca. 1510–1580)
Calypso Attempting to Detain Ulysses
Engraving, printed in red-brown ink, 298 x 215
B.XV.154.171, undescribed working proof
Yale University Art Gallery. Everett V. Meeks,
B.A. 1901, Fund. 1999.76.1 [fig. 6]

☙

16

Marcantonio Raimondi
(Italian, ca. 1480–ca. 1534)
Pyramus and Thisbe, 1505
Engraving, 238 x 214 (trimmed)
B.XIV.242.322; D.134
Yale University Art Gallery. Gift of the
Associates in Fine Arts. 1941.249

17

Marcantonio Raimondi
(Italian, ca. 1480–ca. 1534)
after Albrecht Dürer (German, 1471–1528)
The Glorification of the Virgin, 1504–08
Engraving, 295 x 216
B.XIV.407.637; D.251
Harvard Art Museums. Gift of Belinda L. Randall
from the collection of John Witt Randall. R781
[fig. 24]

18

Albrecht Dürer (German, 1471–1528)
The Glorification of the Virgin, ca. 1500–01
Woodcut from *The Life of the Virgin,* 297 x 214
Watermark: High Crown
B.95; Meder 207
Yale University Art Gallery. Gift of Paul Mellon,
B.A. 1929. 1956.16.2t [fig. 23]

19

Marcantonio Raimondi
(Italian, ca. 1480–ca. 1534)
Young Man Protected by Fortune, 1506–07
Engraving, 147 x 90
B.XIV.286.377; D.289.40 ("doubtful")
Yale University Art Gallery. Gift of the
Associates in Fine Arts. 1941.248

20

Marcantonio Raimondi
(Italian, ca. 1480–ca. 1534)
The Dream of Raphael, 1507–08
Engraving, 235 x 323 (trimmed)
Indecipherable large watermark
B.XIV.274.359; D.176
Yale University Art Gallery. Fry Print
Collection. 1976.49.1

21

Marcantonio Raimondi
(Italian, ca. 1480–ca. 1534)
with Raphael (Italian, 1483–1520)
Massacre of the Innocents, 1513–15
Engraving, 276 x 429
Watermark: Anchor in a circle
B.XIV.21.20; D.8
Yale University Art Gallery. Everett V. Meeks,
B.A. 1901, Fund. 1956.9.48 [fig. 21]

22

Marcantonio Raimondi
(Italian, ca. 1480–ca. 1534)
with Raphael (Italian, 1483–1520)
Il Morbetto (The Plague), 1515–16
Engraving, 195 x 248
B.XIV.314.417; D.189, second state of three
Davison Art Center, Wesleyan University.
1960.14.11 [fig. 22]

23

Marcantonio Raimondi
(Italian, ca. 1480–ca. 1534)
with Raphael (Italian, 1483–1520)
Il Morbetto (The Plague), 1515–16
Engraving touched with watercolor,
195 x 248 (plate)
B.XIV.314.417; D.189, second or third state
of three
Yale University Art Gallery. 1989.1.12

24

Marcantonio Raimondi
(Italian, ca. 1480–ca. 1534)
with Raphael (Italian, 1483–1520)
The Judgment of Paris
Engraving, 293 x 437
Watermark: Anchor in a circle
B.XIV.197.245; D.114
Yale University Art Gallery. Gift of Edward B.
Greene, B.A. 1900. 1928.123

25

Marco Dente da Ravenna
(Italian, ca. 1480–1527)
Copy after Marcantonio Raimondi
The Judgment of Paris
Engraving, 292 x 443
B.XIV.198.246
Davison Art Center, Wesleyan University.
1988.1.164

26

Marcantonio Raimondi
(Italian, ca. 1480–ca. 1534)
with Raphael (Italian, 1483–1520)
Apollo on Parnassus, 1517–20
Engraving, 357 x 471
B.XIV.200.247; D.110, unique first state
The Cleveland Museum of Art. Gift of the
Print Club of Cleveland. 1963.231 [fig. 18]

27

Marcantonio Raimondi
(Italian, ca. 1480–ca. 1534)
with Raphael (Italian, 1483–1520)
Apollo on Parnassus, 1517–20
Engraving, 356 x 470
B.XIV.200.247; D.110, second state
Yale University Art Gallery. University Purchase.
1954.9.9 [fig. 19]

28

Marcantonio Raimondi
(Italian, ca. 1480–ca. 1534)
Trajan Crowned by Victory, ca. 1525
Engraving, 290 x 438
Indecipherable watermark
B.XIV.275.361; D.192
Yale University Art Gallery. Everett V. Meeks,
B.A. 1901, Fund. 1997.41.3

29

Anonymous copy after Marcantonio Raimondi
(Italian, ca. 1480–ca. 1534)
Trajan Crowned by Victory, ca. 1525
Engraving, 283 x 423
B.XIV.276.361 copy
Yale University Art Gallery. Gift of Ralph
Kirkpatrick. 1966.71

30

School of Marcantonio Raimondi
Allegory of Love, 1520–25
Engraving, 384 x 474
Watermark: Anchor in a circle
B.XV.54.11, first state of two
Yale University Art Gallery. Everett V. Meeks,
B.A. 1901, Fund. 1985.49.2

31

Agostino Veneziano (Italian, ca. 1480–1536)
with Rosso Fiorentino (Italian, 1494–1540)
Allegory of Death and Fame, 1518
Engraving, 313 x 511
B.XIV.320.424
Yale University Art Gallery. Gift of Ralph
Kirkpatrick. 1966.94

Digital photography, color separations, and film
by GIST Inc., New Haven. Printing by Thames
Printing, Norwich. Binding by Mueller Trade
Bindery, Middletown. Production supervision by
Yale Reprographics and Imaging Services.

Set in Monotype Bembo typefaces
Printed on Mohawk Superfine paper

Lesley K. Baier EDITOR
Julie Fry DESIGNER